VILLAGES AROUND YORK
THROUGH TIME

Paul Chrystal &
Mark Sunderland

AMBERLEY PUBLISHING

Acknowledgements

Thanks go to the following for their help and advice, and for being so generous with their photographs and postcards; the book would be much diminished without them. Any errors that remain are all mine.

Elaine Armstrong, *Joseph Rowntree School*; Jenny Bell, *Haxby Town Council*; Benjamin Brown; Chris Brown, *Brown's Nurseries*; Melvyn Browne; Carol Carr; Colin Carr; Betty Chapman; Anne Chrystal; Alan Clark; Joe Dickinson; John and Dawn Gates; Julian Gladwin; Mark Harrison, *Huntington Methodist Church*; *Haxby Local History Group*; Chris Headley, *New Earswick Folk Hall*; David Ingham (p.6); Mr and Mrs Lockwood; Richard Ludlow, *Robert Wilkinson VC Primary School*; Ian Mason; Peter Mills, *Harrowells*; Angela Mitchell, *Ralph Butterfield Primary School*; Benjamin Mould; *Northern Scientific (York)*; John Pearson, *York Golf Club*; Carol Prangnell, *Headlands Community Primary School*; Foxton Ronald (Bill) Pulleyn; Nancy Pulleyn; Richard Pulleyn; Philip Roe; Maggi Wright, *Joseph Rowntree School*.

More of Mark Sunderland's work can be found at www.marksunderland.com
For more books on York, its surrounding villages and Yorkshire go to
www.knaresboroughbookshop.com

For Anne, Rachael, Michael and Rebecca

First published 2010

Amberley Publishing Plc
Cirencester Road, Chalford,
Stroud, Gloucestershire, GL6 8PE
www.amberley-books.com

Copyright © Paul Chrystal & Mark Sunderland, 2010

The right of Paul Chrystal & Mark Sunderland to
be identified as the Authors of this work has been
asserted in accordance with the Copyrights, Designs
and Patents Act 1988.

ISBN 978 1 84868 897 1

British Library Cataloguing in Publication Data.
A catalogue record for this book is available from
the British Library.

Typeset in 9.5pt on 12pt Celeste.
Typesetting by Amberley Publishing.
Printed in the UK.

Introduction

With a highly photogenic and historical city like York on the doorstep it is easy to overlook the many picturesque villages surrounding the city – each of which has their own individual heritage and historical significance. This book tells the story of five of those villages in pictures and in words and demonstrates how their heritage lives on today, how it has changed or how it has disappeared. It does this by juxtaposing contemporary photographs with older ones so that each page gives a fascinating 'then and now' picture of the villages and the villagers. Informative captions complement the pictures and, in so doing, provide what is effectively a brief history of each village from earliest times up to today.

The five villages here to the north of York have a number of things in common: they are each close to or on the River Foss; they were all until fairly recently agricultural communities and they are now all pleasant and rewarding places to live in – largely but by no means exclusively for workers in York and further afield. They also have characteristics which are unique to themselves.

Haxby – politically a town but still very much a village at heart – is the largest of the five. *The York Herald* put it very well in 1911 when it said : *"Haxby is a peaceful spot and one can understand that the office workers of the city of York who live here find rest and refreshment in the sight of field and garden at the close of day"*; the same can still be said today in 2010.

Likewise Wigginton – smaller than Haxby and often unfairly overlooked as a result – it has its own history and character which are well worth experiencing and exploring.

Strensall will always be associated with the military and the Army has certainly exerted a strong influence on the village – but there is more to it than that, as shown here by the intriguing histories of schools and churches. York Golf Club on the edge of the village provides another fascinating story.

Huntington too has a fine church, a fine Hall and some wonderful stories from down the ages involving royal pardons, cavalry officer chivalry, Zeppelin raids and bomber crashes.

New Earswick, much younger, is world famous for Sir Joseph Rowntree's innovative and visionary garden village, putting it at the forefront of early twentieth century social reform in Britain. Many of us pass through the village every day forgetting, I'm sure, just how important it is in the history of social welfare.

A book like this is, of course, only as good as the photographs it contains. The majority have been provided by the individuals and institutions acknowledged above; their generosity ensures that the history of these villages lives on a little longer and can be enjoyed and researched by future generations. Special mention must be made of Melvyn Browne, Joe Dickinson, The Haxby Local History Group and Colin Carr for allowing me to plunder their collections, and to Joseph Rowntree School for allowing us access to the newly opened school – a truly significant local development and a massive benefit to the future of all five villages. The new school is a fitting early twenty-first century testament to Joseph Rowntree's early twentieth century vision.

So, a book to be dipped into or read straight through as a glimpse of aspects of English history through five villages from the Norman Conquest to the early twenty-first century. It will interest, entertain and inform local resident and visitor alike and indeed anyone who has moved away from the area and needs a nostalgic reminder of what they remember and how far it has changed. If it inspires the reader to pursue their local history further then it will have achieved its aim.

The modern photography is by Mark Sunderland; he has done a marvellous job to show the 'now' – despite the ravages of time, relentless traffic, rampant foliage and so-called street furniture.

The style and ethos of the *Through Time* series precludes the use of footnotes or references; I would nevertheless like to acknowledge the following publications which have proved informative and helpful:

Alley, E. *Discovering New Earswick*, York 2009

Carr, C. *Huntington Revisited*, York 2009

Chrystal, P. *York Then & Now*, Stroud 2010

– *Chocolate in York: A History*, Barnsley 2011

Clark, A. *Thomas Johnson 1873-1947 The Haxby Cobbler*, Haxby 2006

Fife, M. *The River Foss: Its History and Natural History*, York 1981

Haxby Local History Group, *Haxby in Wartime*

– *The Happiest Days: Education in Haxby 1854-2004*

– *The Haxby Town Trail*

– *Haxby Remembered*

– *Bricks and Brickmaking in and Near Haxby in the Vale of York*

Joseph Rowntree Village Trust, *One Man's Vision: The Story of the Joseph Rowntree Village Trust*, London 1954

Mitchell, T. *Strensall in the Mid Nineteenth Century*, York 1989

– *Foss Navigation*, York 2000

Moore, G. (ed) *This is Wigginton*

Murphy, J. *New Earswick: A Pictorial History*, York 1987

Neal, D. *Huntington Board School to Primary School 1877-1977*, Huntington 2009

Page, W (ed) *Victoria History of the County of York North Riding Vol 2*, London 1923

Pearson, J. *York Golf Club 1880-1990*, York 1990

– *Through the Green* (June 2004), pp 20-22

Smith, T. *A History of Haxby* (rev ed) York 2003

Strensall Local History Group, *Strensall Then and Now*, York 2006

Windsor, D.B. *The Quaker Enterprise*, London 1980

Paul Chrystal, July 2010

CHAPTER 1

Haxby & Wigginton

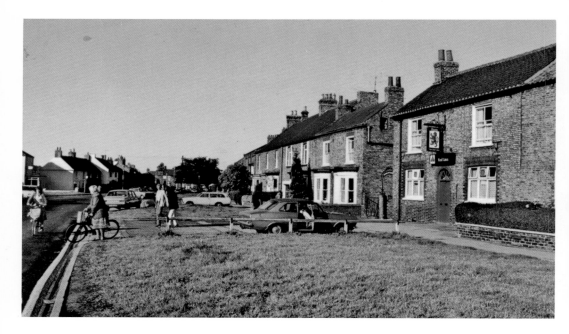

The Village looking west

Looking down The Village in the 1970s with the Red Lion on the right. Up until the second half of the twentieth century the 2000 acres of the parish were almost totally devoted to agriculture with 1100 acres under cultivation and 800 as pasture at the time of enclosure in 1769. Parish registers from around 1850 show that of the 218 men recorded 144 were farmers or farm labourers and a further 46 were in trades supporting farming such as blacksmiths and carpenters. The *1941 Farm Survey* shows there to be no fewer than 38 farms in and around Haxby including many, like the 107-acre Church Farm at what is now 44 The Village, in the centre of the village itself.

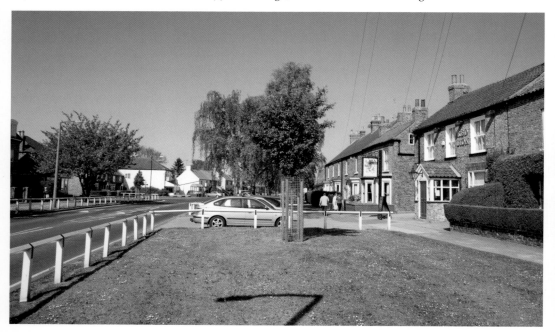

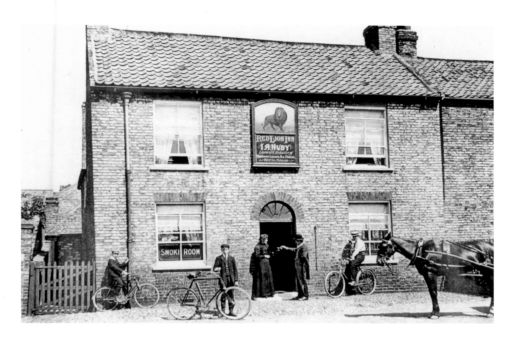

The Red Lion

The Red Lion appears on Ordnance Survey maps from the mid nineteenth century. Bicycles and horse and cart feature in this Edwardian photograph. Apart from its function as a hostelry the Red Lion also served as an eighteenth century business centre: the meeting to finalise the construction of the two miles of the Foss Navigation north of Haxby was held here in May 1795 with a cost of £460 being agreed with contactors John Harrison & Co. The other old village tavern was, and still is, the Tiger Inn, first mentioned in records in 1840 when two cottages and a blacksmith's were converted to make it into a public house.

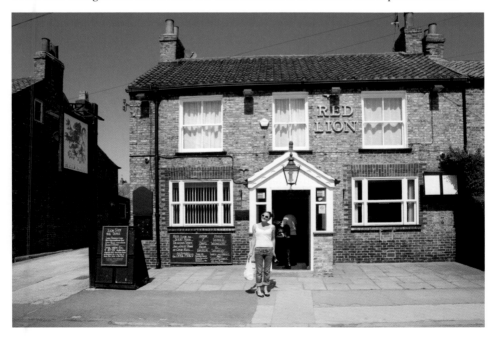

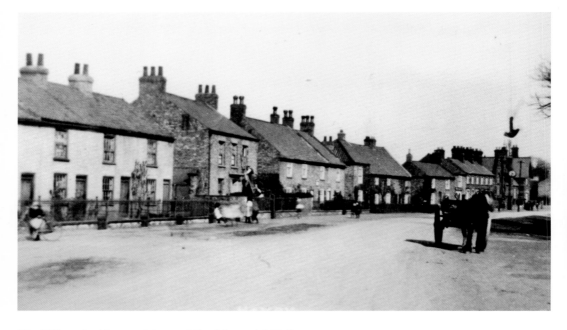

The Village looking east toward the Memorial Hall

Haxby's entry in *Domesday*: *"6 carucates* (the amount of land you could plough in one season), *1 bovate taxable, 4 ploughs possible. St Peter had it and has it. There are 7 villagers and 3 ploughs. Value pre 1066, 20 shillings, now 10 shillings."* The devaluation was a result of the destruction caused by William I's Harrying of the North – his scorched earth campaign to subdue revolting northerners. Brick and tile making was the other main industry here with five different brick makers recorded in 1881, all exploiting the rich clay seam under Haxby's topsoil. They were concentrated in North Lane and on Usher Lane and behind York Road (numbers 103 and 105 where the brick ponds, now fishing lakes, can still be seen). The 1881 census shows us eighteen people in Haxby in the brick and tile business, the most prominent of which was the Driffield family.

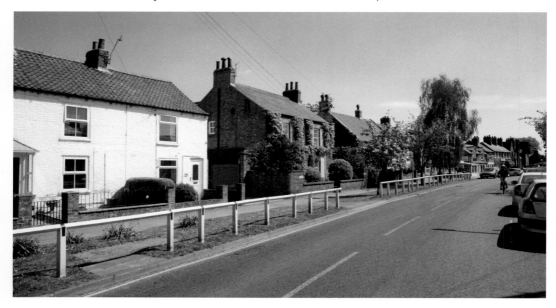

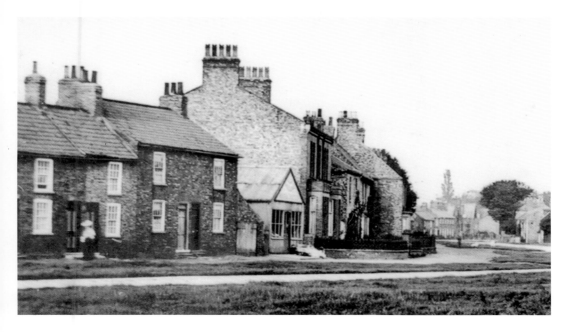

The Old Haxby Co-op

This gabled corrugated iron building in The Village opened in 1904 as the Haxby branch of the York Equitable Industrial Society selling groceries, drapery and boots. Celebrations for the opening included tea and a concert attended by 200 people. Further down at number 50 (in what has been the Spring House Tea Rooms since 1985) was another idiosyncratic building: the left hand section was the rate office where the Parish Clerk collected rates, doubling as a fish shop in the evening. The right hand side of the building housed the village fire pump which was wheeled out once a year for a good polish.

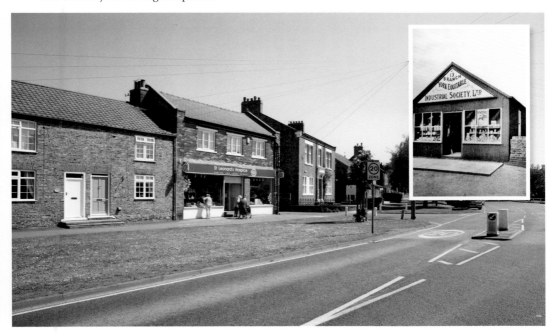

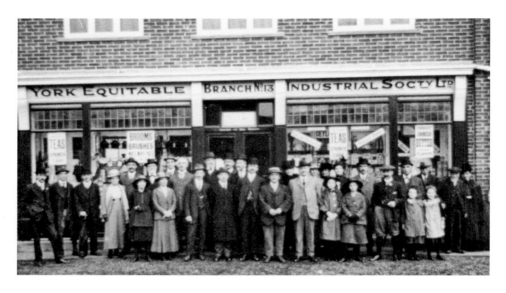

The New Haxby Co-op

The second Co-op was in the building now occupied by the St Leonard's Hospice charity shop further down The Village from the earlier Co-op building. The older photograph shows the opening in 1920 of the new shop which was in turn replaced by the present supermarket in Ryedale Court in 1986. The Co-op grew out of The Rochdale Society of Equitable Pioneers – a group of 28 weavers and other Rochdale workers – in 1844. At the time, increasing mechanisation was causing growing unemployment and poverty, so they opened their own shop selling food they could not otherwise afford. Over four months scraped together £1 each to raise £28 capital and on 21 December 1844, they opened their shop with a meagre stock of butter, sugar, flour, oatmeal and candles. After three months, tea and tobacco were added and they soon won a reputation for high quality provisions. By 1854, the co-operative movement had nearly 1,000 shops.

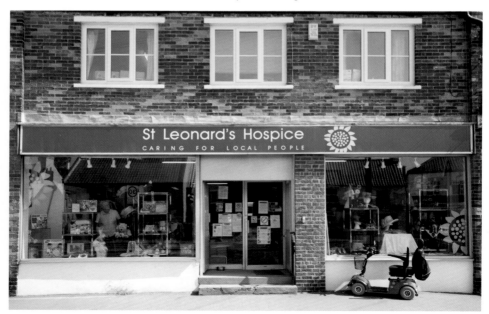

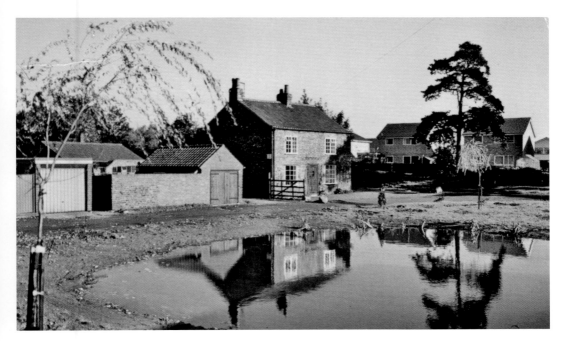

Wyre Pond

Little has changed in this pleasant corner of the village since the original 1960s photograph. The scene of perennial flooding, partly due to all the rubbish that had been tipped into it over the years, it was filled in in the 1940s and re-excavated in 1977, flooding problems largely resolved as a result. Wyre is Anglo Saxon for pond thus indicating the pond's antiquity. Some of the cottages nearby date from around 1820.

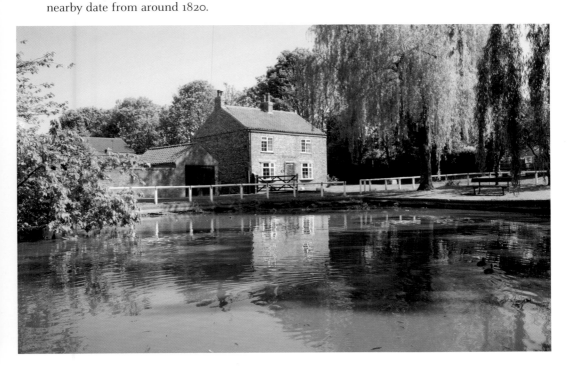

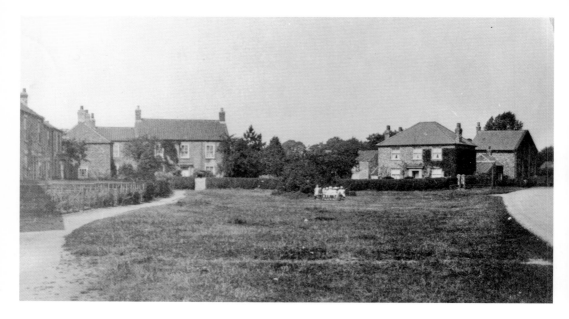

The Green and Haxby Dames' School

Some of the houses here are early eighteenth century. Prominent among them are Prospect House, originally the farmhouse for Prospect Farm until the 1950s. The copper beech was planted to commemorate George V's coronation in 1911. In the nineteenth century the Dames' School classroom and accommodation for the teachers were at numbers 65 and 67; fees were 3*d* per week. Dames' Schools were small private schools set up to provide working class children with a basic education before they were old enough to go to work. They were usually run by women who taught the children to read and write and other useful skills such as sewing. The quality of education varied enormously: some provided a good education, whereas others were little more than crèches.

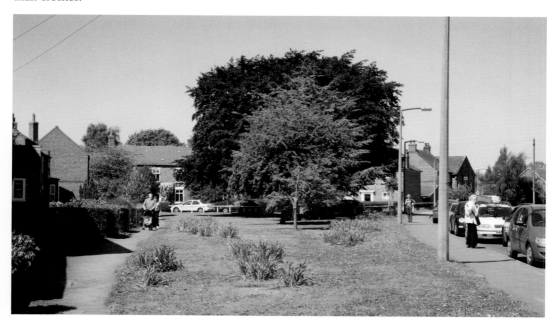

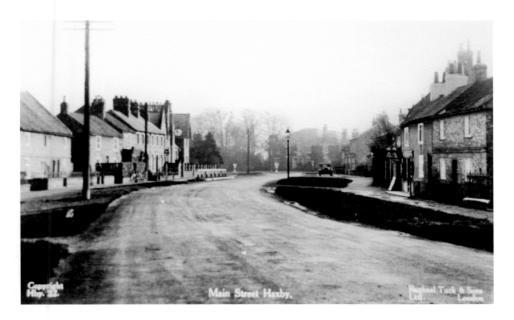

The Haxby Cobbler

Thomas Johnson – the Haxby Cobbler from 1922-1940 – lived in Pear Tree Cottage – in the middle here on the right, now 31 The Village; before that he had lived at 57 The Village (now Churchill's Estate Agents) and at 4 West View Terrace. The business was run from premises next to the Primitive Chapel, demolished in 1930. This description from Alan Clark's book on Johnson gives some idea of living conditions around 1908: *"A single living room with a cupboard under the stairs for coal, a pantry with shelves off the living room with a tiny alcove housing a tap and sink. The toilet was outside at the end of the garden. Stairs off the living room gave access to the two bedrooms. With no gas or electricity the coal fire was needed to boil the kettle and make toast. An oil lamp provided lighting when required."*

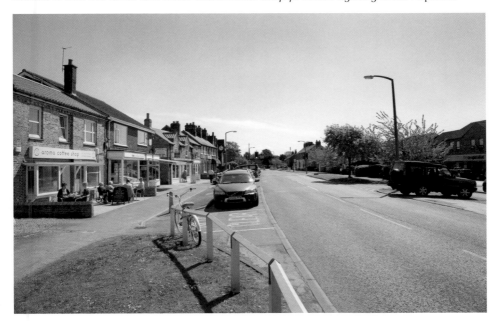

Wortley House

Wortley House at 70 The Village, now Dr W. Inness' dental practice, on the far left, then Miss Jefferson's sweet shop at 64 The Village, now Paddyfields Cantonese restaurant (Grant's restaurant before that). Today's picture shows the fine building that is Wortley House: it has the distinction of being the only building in the village not to have surrendered its railings for the war effort – they were concealed behind thick hedging at the time of collection. The house has long had a public health connection: before becoming a dental practice it was the home and surgery of Dr A. W. Riddolls between 1932 and 1960; pre-NHS consultation charge was 1s 6d (7½p).

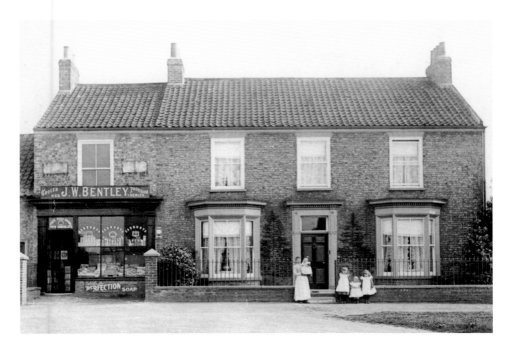

Bentley's

Village grocer's, taken around 1905 with North Villa next door. It later became Asquith's and in the second world war it was Wm Thompson, grocers of York. It eventually became Foxton Bell's Central Garage and Showroom before demolition to make way for Clark House and the £1m Haxby Shopping Centre. The garage was a Ford and Austin main dealer; contemporary advertisements tell us they offered: *engine reconditioning using modern equipment, high pressure washing and lubrication, recellulosing and body repairs.* Abel's Farm was also sold to make way for the arcade; nearby Abelton Grove is named after Mr Abel. The new photograph shows Haxby's other shopping arcade: Ryedale Court further down The Village.

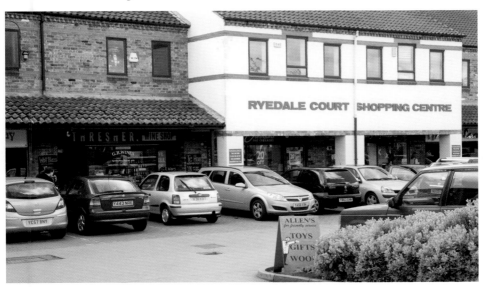

Fish and Blitz
Walker's Fisheries 1938; now
55 The Village. The children
are (l-r) Mavis, Jack and Joyce
Walker. Walker's offered "*All
kinds of Wet Fish, Kippers,
Finnan Haddocks etc; Fresh
supplies daily – all orders
promptly attended to*". In 1945
Walker's had an unfortunate
visit from the Luftwaffe
when a lone fighter strafed
The Village with cannon fire,
narrowly missing a bus and
shattering the shop window
– no one was hurt. It is now
a pizza takeaway next door
to the current fish and ship
shop, Miller's.

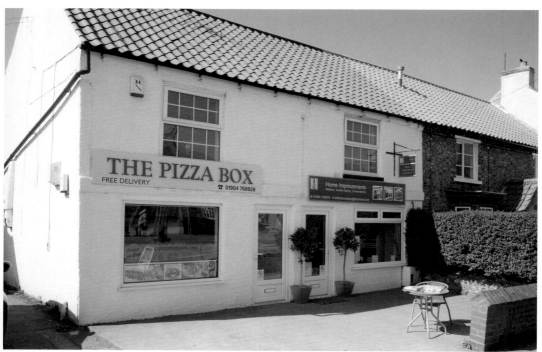

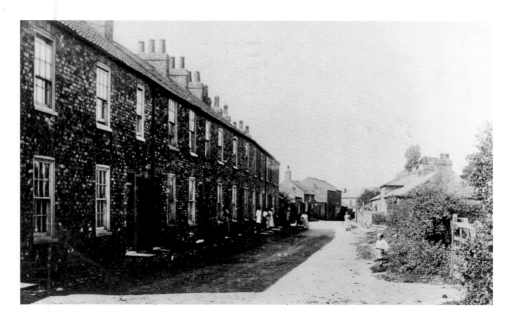

North Lane

North Lane and South Lane were back lanes designed to give access to the farms along The Village. Entries in the Liberty of St Peter petty court sessions court book give some idea of just how dominant agriculture was in the village:

"Thomas Plowman of Haxby, farmer and John Whitwell of Tadcaster, grocer v John Halton of Haxby, husbandman. Rent in arrears, property neglected and deserted, so Plowman given possession 3 Oct 1835.

Thomas Plowman of Haxby, gentleman, Thomas Hodgson of Towthorpe, gentleman, and Samuel Wilkes-Wand v William Wailes of Skeldergate, York, innkeeper. Trespassing in pursuit of game 28 Nov 1835."

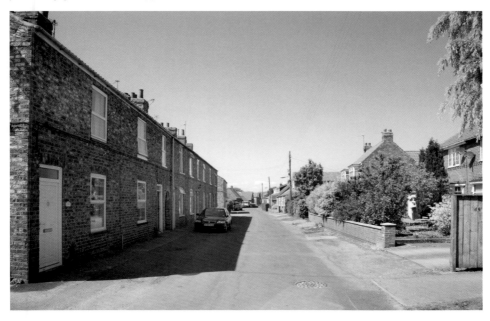

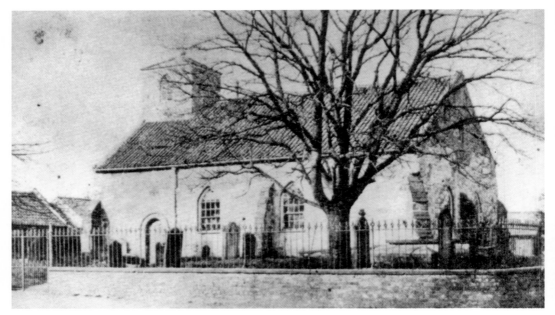

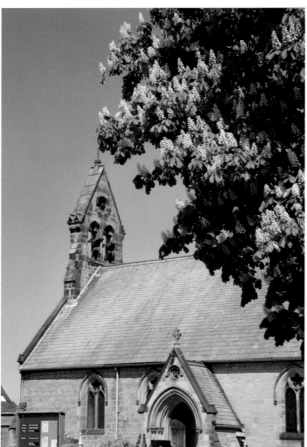

St Mary's Church

The new photograph shows St Mary's Church; this was built in 1878 in Gothic style at a cost of £1800 on the site of the Chapel of Our Lady which had burned down and is pictured here in a very early photograph. St Mary's has a single bell on which *"fili dei miserere mei 1621"* is inscribed. Initially the original church had no burial licence and there are stories of corpses being 'casually lost', as happened to a certain Thomas Westeby whose body, on the way to being buried at Strensall Church, "by reason of the great distance and the badness of the ways" fell into the River Foss. The earlier chapel owned a number of properties for which the rent was payable in hens and eggs.

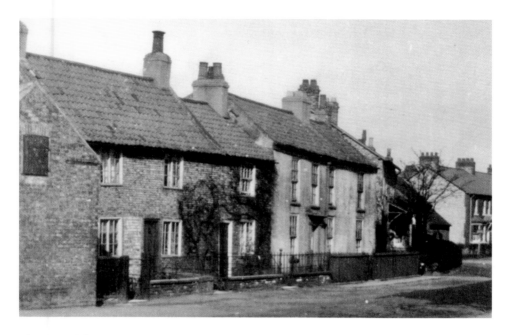

The Roundabout

Widd's Farm was near to where Westow House is now. Westow was originally a private residence; Harrowells solicitors occupied it in 1985 at the time the adjacent Ryedale Court shopping centre was built and opened. Harrowells was established, in York, in 1908 and now has around 130 staff still based mainly in York with the subsidiary offices in Clifton Moor and Haxby. A tree was planted at the roundabout for the coronation of Edward VII in 1903. The farm on the corner of York Road and The Village was imaginatively called York Road Corner Farm, demolished in 1929 to make way for Norbryte House which accommodated the Post Office...

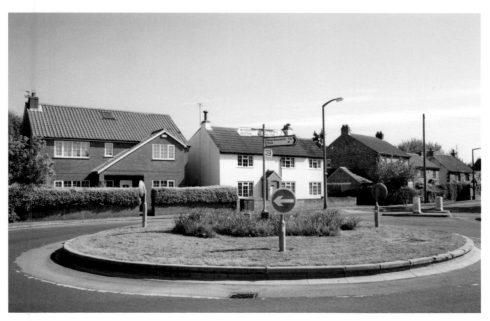

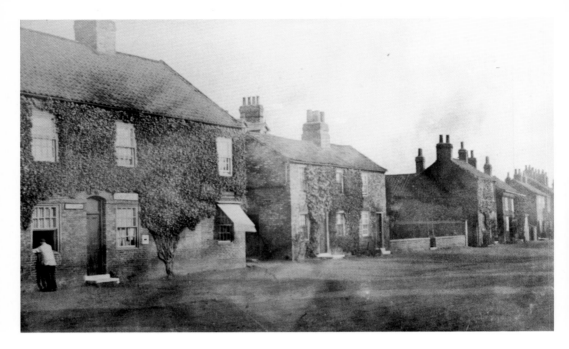

...The Post Office

The Post Office on the corner was very much a general store selling, amongst other things: hardware and crockery, fancy drapery, fresh fruit, drugs and patent medicines, corn, offals etc. Adverts from the 1950s boast: *"We sell all the best makes of chocolate and sweets"* and exhort us to *"Just give us a trial; we can satisfy you"* and *"Remember the resident traders first"* – a sentiment that deserves to be echoed more than ever today.

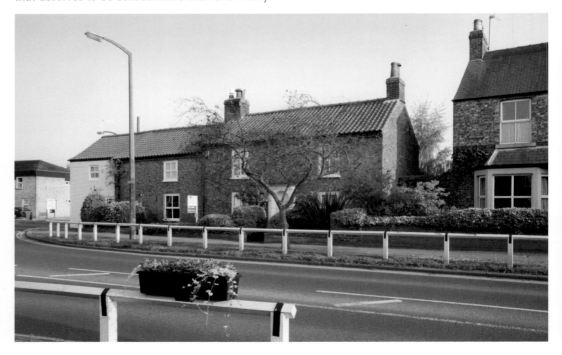

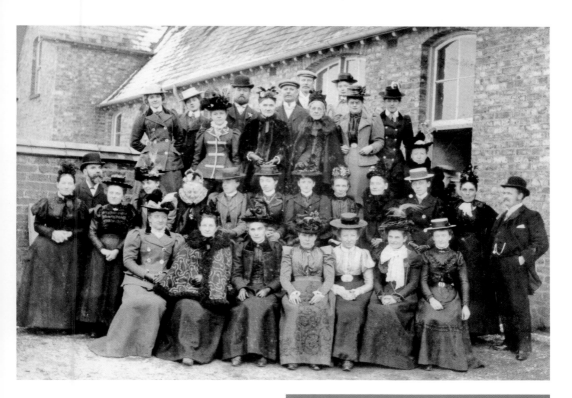

Haxby Board School

The first school in Haxby was where the Tiger is now; this was superseded by the 1851 school: The Church of England School "for the children of the labouring poor of Haxby" – sixty boys and eight girls; staff comprised the head, a sewing mistress and a pupil teacher; this is now St Mary's Hall in North Lane. The Board school opened in 1876; it cost £2,200 and had fifty-three pupils on roll. The Revd Hodgkinson, vicar of Haxby around 1851, was one of the early fundraisers. Early school governors though, seem to have missed the point completely; this from the day book for 8 November 1878: "The registers have not been marked since Monday for the following reason, viz on Tuesday members of the board...came to the school and with sticks violently drove the children, some out of the school, and others from getting in." The school is now the Memorial Hall dedicated to the memory of the Haxby fallen in the World Wars: 27 in the First World War (3% of the population) and 9 in the Second World War.

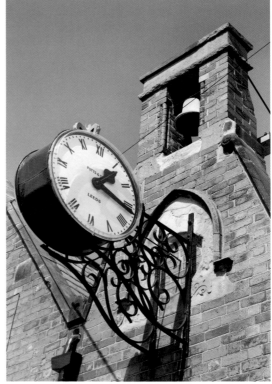

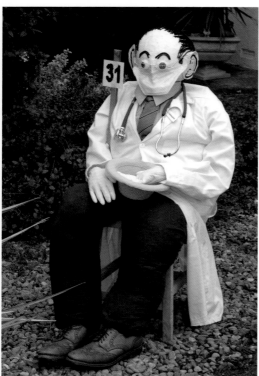

Haxby ARP and First Aid Post 1941
Nurses and first-aiders outside Haxby Hall.
Mavis, Jack and Joyce Walker make another
appearance here on the back row while
Dr Riddols can be seen on the front row
in the centre. The modern picture shows
a medically-themed entrant to the 2008
Haxby and Wigginton Scarecrow Festival
– a very popular event organised by the
Methodist Church with all funds raised
from the one hundred or so entrants going
to charity. In 2010 the £3,000 raised went to
the Haiti Appeal, Christian Aid and to local
projects.

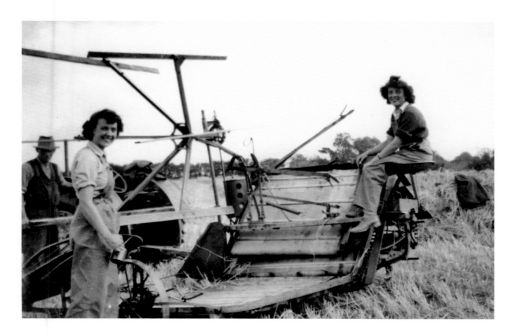

Tiller girls in Haxby

Women's Land Army girls on the binder on the Lazenby farms (The Grange House and Grange Farm on Crossmoor Lane). The Grange comprised 102.5 acres split roughly 50/50 between arable and pasture. The main crop was wheat; 180 chickens, 8 horses, 24 cattle, 3 pigs and 6 sheep comprised the livestock. The farms were also home to a wartime searchlight battery manned by the Haxby and Wigginton Home Guard commanded by Tom Pulleyn, local builder. Their HQ was in the then WWI Memorial Hall in South Lane and training was at Strensall Camp. Between 14 February 1941 and 23 September 1943 there were eighteen air raid warnings in Haxby and six major incidents in the area.

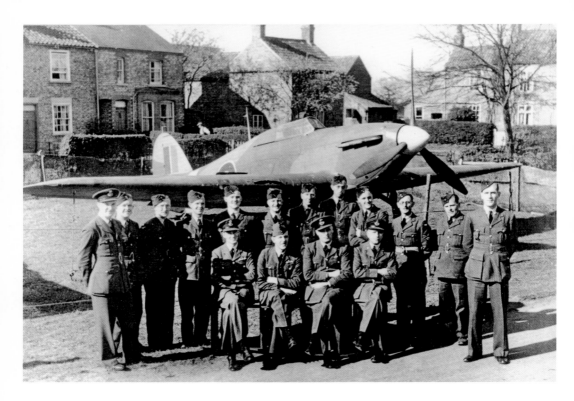

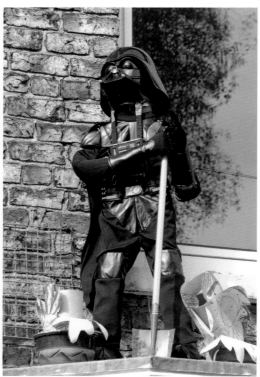

Hurricane hits Haxby

Salute the Soldier Week (a national war effort fundraising effort) May 1944 with personnel from 60 Maintenance Unit RAF and a repaired Hawker Hurricane on the village green. This crashed aircraft recovery unit was stationed at Shipton and repaired mainly Halifax bombers; some of the personnel were billeted in Haxby. They also requisitioned Wigginton Recreation Hall (a wooden building on the site of the current hall built in 1984) and held Friday night dances which were very popular with locals and servicemen and women from Strensall and York; French troops from Elvington and Canadian airmen stationed at Eastmoor near Sutton. RAF film shows were shown on Wednesday nights.

The modern shot shows a contemporary, albeit fictional, threat to world peace. This entry from the Scarecrow Festival is Darth Vader, the terrifying cyborg, commander of the brutal Galactic Empire.

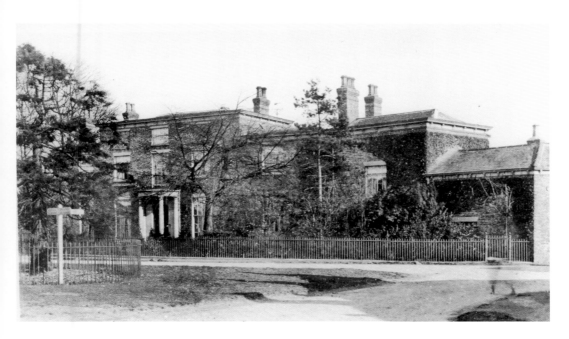

Haxby Hall Vandalised

A good example of 1960s planning vandalism where a perfectly fine building was replaced with the dullest construction imaginable to serve as a home for fifty-two elderly people and ambulance station in 1965. The original Grade II listed building situated in 22 acres was built in 1790; an unusual, striking feature was the glass cupola over the stairwell. Notwithstanding, it was demolished in 1963 despite local protests. It had started life as a private residence and was used up to 1853 as the Revd John Heslop's Classical and Mathematical Academy for "Sons of Gentlemen of high respectability; £50 pa including washing." In the Second World War it was requisitioned to accommodate evacuees from Hull and Middlesbrough as well as being the local First Aid centre and HQ for the ARP (see p.22).

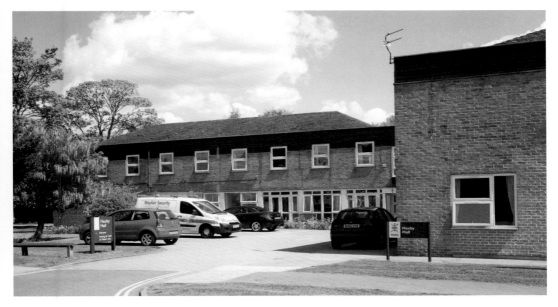

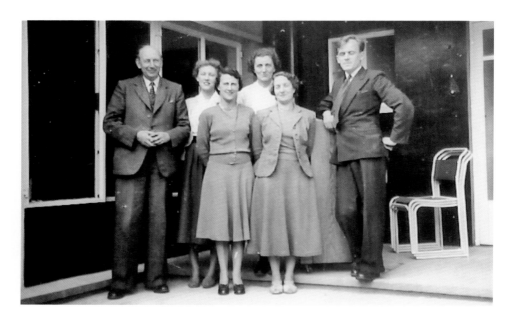

Ralph Butterfield County Primary School 1954 and 2010

The school was named after and honours Ralph Butterfield OBE, a prominent North Yorkshire educationalist who also distinguished himself at Passchendaele where he won the Military Cross. The staff are (l-r): Mr Basil Hurdus (Head); Miss Smith; Miss Curry; Miss Francis; Mrs Hollinrake; Mr Jack Fall (later Head at Headlands). Basil Hurdus was a Headmaster in Haxby for twenty-six years until his retirement in 1964. At its opening the school accommodated 200 children in 5 classrooms at a cost of £30,684 with a further £2,650 for furniture. In 1965 pupil numbers were 242, 7 of whom passed the 11+ that year. In 1970 a growing population led to the building of the Usher Lane annexe (which in 1974 became Oaken Grove School, closed in 2002). The modern photograph shows the 2010 teaching staff less Anne Chrystal, Year 5 teacher, who took the photograph. The Head, Angela Mitchell, is fourth from left.

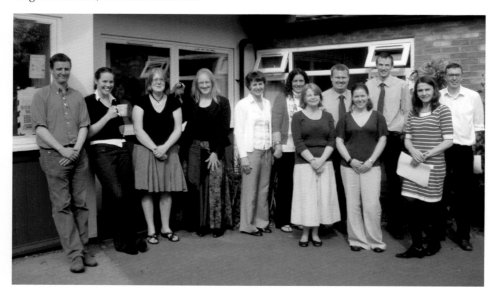

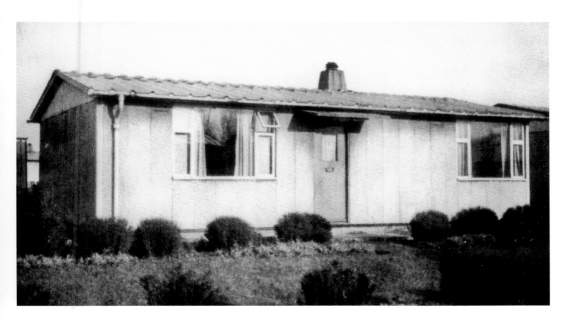

Whiteland Cottages, Usher Lane

Named after one of the four pre-enclosure arable fields in the village (the others were Lund, Mill and York). These Tarran prefabs went up after the Second World War; they were finally defabricated in the 1990s and replaced with the sheltered housing seen below. Over four million homes were needed at the end of the war to replace bombed stock and to house the record two million or so couples who had married during the war. £150m was voted to build prefabs such as these and by July 1948 160,000 had been snapped together at a cost of £216m. There were a number of different designs, the most common being the Arcon Mark V; the Airoh was made from left over aircraft materials. All had two bedrooms, fitted fridge, heated handrail, coal fire with back boiler, inside toilet, fitted wardrobes.

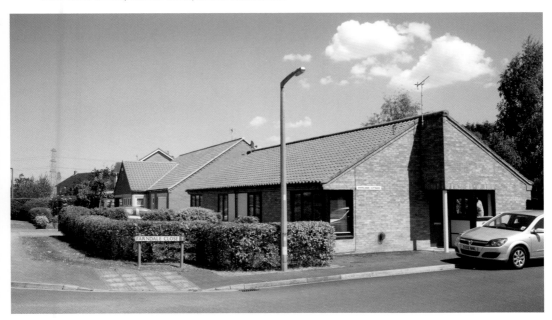

Swarthdale 1977

In 1977 Swarthdale, in what used to be known as Usher Park, ended at number 30 (on the right here) Beyond was open countryside which was only later developed into the long loop road it is now, merging into Usher Park Road. The older photograph shows Alan Chapman of number 28; his widow, Betty, still lives there. Goland Cottages are opposite on the other side of Usher Lane – named after nearby Goland Dike, a tributary of the River Foss. During the Second World War a Nellie Howes lived in a railway carriage parked in Usher Lane. The lane was named after the Usher family who lived near the junction with Station Road; Windmill Lane got its name from the brickwork's windmill which stood where the junction is now with Usher Lane; it was demolished in 1950. Swarthdale may be named after the village of Swarthdale on Swarth Beck near Over Kellet, Carnforth in Lancashire, or after Swarthdale Springs south of Hovingham. There again, it may just have been made up...

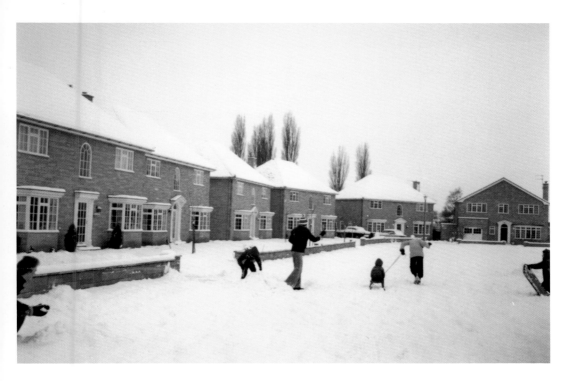

Swarthdale in Snow

The only real differences today are the trees and mature gardens you would expect after 30 years. Usher Park is symptomatic of the house building boom in Haxby and Wigginton in the 1970s and 80s to accommodate the increasing population. In Haxby alone it grew from 3,783 in 1971 to 9,064 in 1981 (it had been 711 in 1901) – a 240% increase in 10 years. Apart from housing, the growth led to two new schools – Oaken Grove and Headlands – an extension at St Mary's, a Roman Catholic church (St Margaret Clitherow) and other essential shops and services.

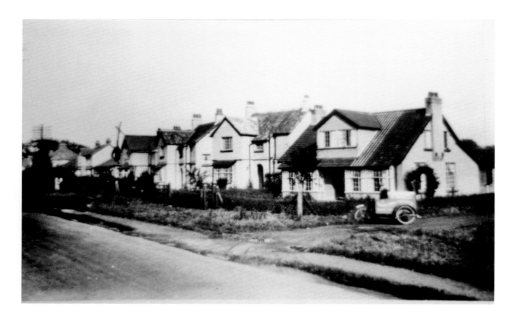

Park Estate

Built in 1922 this is now The Avenue; the new photograph shows the range of architectural styles of the houses on the development. In the inset we can see builders from Pulleyn's at work. They are (l-r) Francis John Pulleyn, Mr Copley, Stanley Pulleyn and Verdun Pulleyn. John Pulleyn started the building business; his son, Francis John, set up the family brickworks. Nearby on York Road is The Old House where Tom Holtby lived after his retirement from stagecoach driving, forced due to the advent of the railways. He had a horse breaking business in Minster Yard, York and then invested in a brickyard in Haxby. This, like his other ventures in banking (lost over £800) and newspaper ownership (lost £600), was financially disastrous for him although he still managed to leave £3000 to the village on his death in 1863.

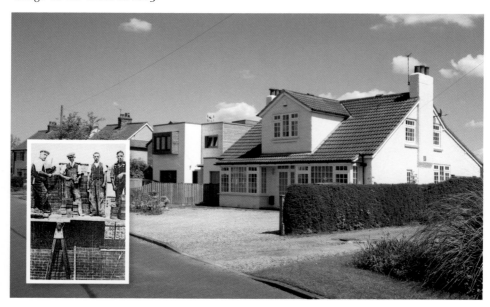

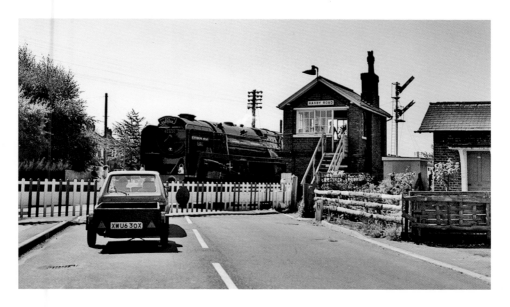

Haxby Gates and Haxby Station 2013?

British Railways Riddles 'Standard' 9F 2-10-0 locomotive number 92220 "Evening Star" rushing past Haxby Road signal box (demolished 1988) as the 08:23 Scarborough Spa Express, Sunday 14 August 1983. Haxby's station, where Pulleyn's garage now is on Station Road, opened in 1845; it was closed to passengers in 1930 but remained open for freight and coal for some years after. Goods included boxes of fish, Lyon's cakes, calves, animal feedstuffs, straw, grain and soldiers on the way to Strensall. *The York Herald* of 12 December 1864 carried a report of a fatal accident enquiry. Thomas Hawcroft, stationmaster at Haxby, was run over by a wagon while trying to help his porter and later died after his foot had been amputated. A new station is proposed for 2013; it will have a car park with 80 spaces. Projections are for 190,000 passengers pa (530 on average per day) with 44% going to York and 40% to Leeds; 40% will come from within ½ mile or less and 80% under a mile.

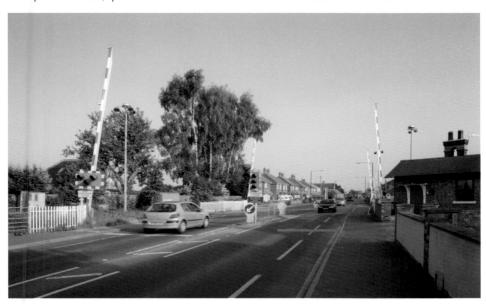

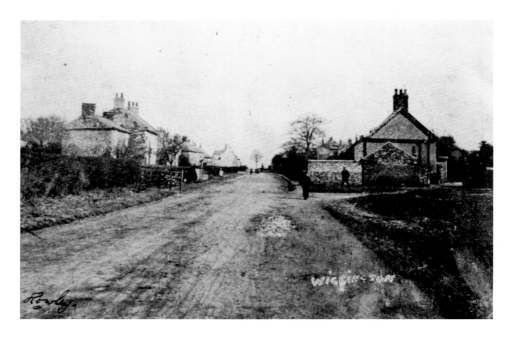

Wigginton's Mill and the Parish Bull

This is looking down The Village from Wigginton pond with Manor Farm on the right, about 1910. Mill Lane is named after the mill that stood on Sutton Road opposite the Shipton Road junction, now the site of Windmill House and the Windmill Trading Estate. It features on the 1769 enclosure map. The Windmill public house was next door, demolished in 1930. In 1906 revenues from the land in Wigginton amounted to £11.00; 6s.8d of which was paid for tithe, 30s to 10 deserving poor and the rest for the services of the parish bull who performed in the Bull Field, now Mill Lane playing field. In 1791 the fee per cow was 1s; the last bull came and went in 1952.

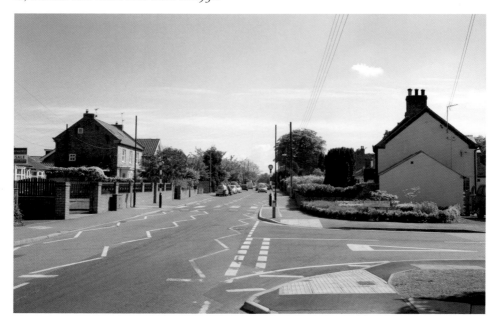

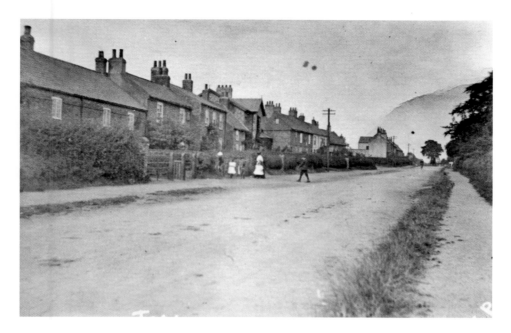

Wigginton and the Harrying of the North

Further down the road about 1895. Wigginton's entry in *Domesday* reads as follows: "*In Wigginton there is one curucate, taxable, which one plough can plough, Saex Frith the Deacon* (from which Saxford Way) *held this, now St Peter has it. It was and is waste; there is underwood here.*" The 'waste' was due to the devastation caused by William I's soldiers in the Harrying of the North (see p. 8). The reference to St Peter indicates that the church owned the land. Around 1777 local church fees included: burial inside the church 10s (50p), 10d for burial in the churchyard with a coffin, 5d without; wedding licence 10s, banns half a crown [12½p]. Population in 1801 was 260, 340 in 1901 and 3,714 in 2001.

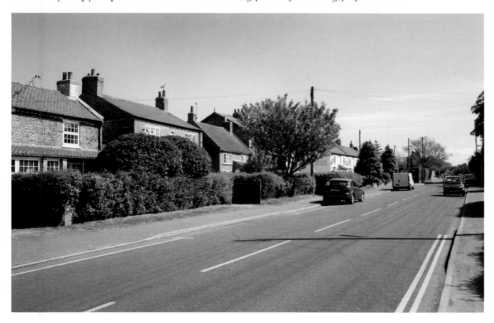

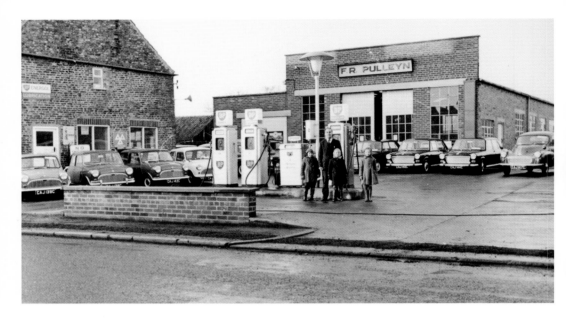

F. R. Pulleyn Wigginton Garage

Foxton Ronald (Bill) went into the motor trade at age fourteen and by the time he retired he had three garages: one in Haxby which is still thriving under Richard Pulleyn, one in Wigginton and one on Wigginton Road. He set up the first of these in 1958. The photographs show an impressive display of Morris motorcars in 1960 and some early Minis. The children posing for the photograph are Barbara and Richard Pulleyn with next door neighbour, Margaret Cass. Behind the garage was a blacksmith's worked by Victor Pulleyn who previously drove mule trains in the army in Mesopotamia (modern-day Iraq) during WWI; a corn mill and steam engine also operated there.

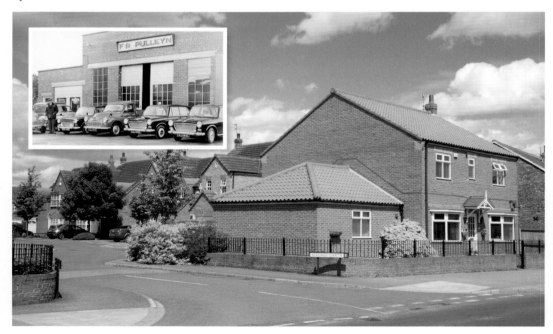

Wigginton School and the Relief of Mafeking

One of the finest buildings in Wigginton. Boys entered through the kitchen, girls at the other end of the building; a wall down the middle of the yard segregated girls and boys at playtime. This is the second school in the village, the first having been opened in 1835 by Miss Anne Dealtry in Rectory Cottage, close to Rosevale nursing home. Attendance was a chronic problem, described in 1876 as "sadly irregular and neglected" due largely to "potatoeing and haymaking" and, on one occasion in May 1900, the Relief of Mafeking. Poor attendance resulted in poor academic standards. The second school, pictured here today, was opened in 1904 and was eventually replaced by the present school in Westfield Lane in the late sixties. The older pictures show a rather poignant circular distributed to local schools recommending prayers suitable during the Great War years.

NORTH RIDING COUNTY COUNCIL EDUCATION COMMITTEE.

Prayers for use in Schools in time of War.

I.

ALMIGHTY FATHER, we Thy children pray Thee to help our country in this time of war. Defend our sailors, soldiers and airmen, and those of our Allies, in all dangers and grant them victory and good success. Comfort the wounded, the sorrowful, and the sick. Teach us to be loving and unselfish at home, and grant us the blessing of peace in Thy good time, through Jesus Christ our Saviour. Amen.

II.

O LORD God of Hosts, stretch forth, we pray Thee, Thine Almighty Arm to strengthen and protect the sailors, soldiers and airmen of our King, and those of our Allies, in every peril, both of land and sea and air, especially our own fathers, brothers and friends, and others who have gone forth from this place. Shelter them in the day of battle, let Thy Holy Angels watch about them, and grant that in all things they may serve as seeing Thee Who art invisible, through Jesus Christ our Lord. Amen.

III.

LOOK, we beseech Thee, O Lord, upon the people of this land; and grant that in this time of trouble they may walk worthy of their Christian profession. Give to us Thy children grace to fulfil our daily duties with a sober diligence, and keep us from all unkindness in thought, word and deed; through Jesus Christ our Lord. Amen.

IV.
For Evening Prayers.

O GOD, Who never sleepest, and art never weary have mercy upon those who watch to-night; on the sentry, that he may be alert; on those who command, that they may be strengthened with counsel; on the sick, that they may obtain sleep; on the wounded, that they may find ease; on the faint-hearted, that they may hope again; on the light-hearted, lest they forget Thee; on the dying, that they may find peace; on the sinful that they may turn again—and save us, O good Lord. Amen.

NOTE.

One or more of Nos. I., II., III. may be used each morning and evening No. IV. is for evening use only.

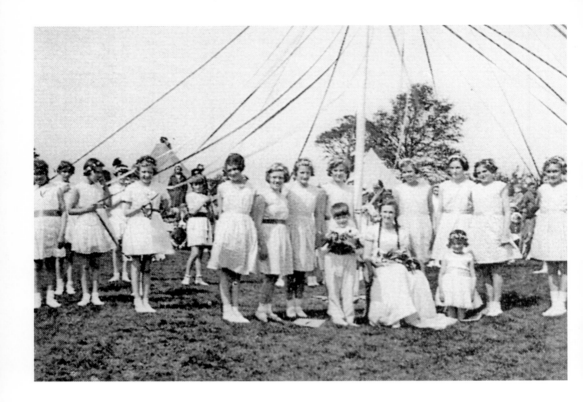

Wigginton Carnival and a Zeppelin raid

An annual May Day event, this shows maypole dancing just before the Second World War; the May Queen was Betty Donald, the daughter of the then rector. The modern photograph shows another entry from the Haxby and Wigginton scarecrow festival. Wigginton, like Haxby, had a thankfully quiet time during the world wars: the first war saw a Zeppelin bomb the B1363 nearby and the second brought refugees, including a group of children fortunate enough to have escaped the Channel Islands shortly before the German invasion, chaperoned to Wigginton by a Madame de Routon. A Halifax bomber crashed into a field where Windsor Drive now is and an RAF lorry ran over and killed a local tramp, Richard Dickinson, nicknamed Dick Dick, famous for his bad temper and wooden leg.

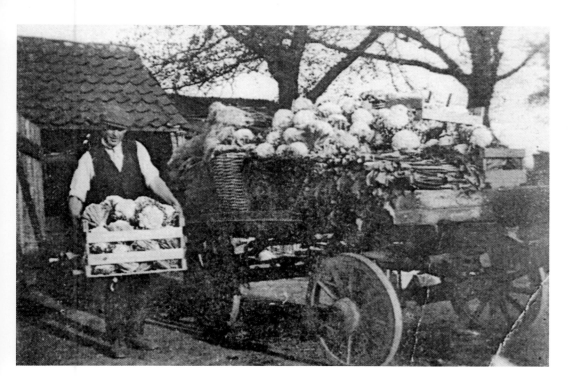

Brown's Nursery

Chris and Kathy Brown run the present Brown's Nursery in Corban Lane; they are the fourth generation of nurserymen in the Brown family in the village, their original premises being in Mill Lane close to where the Sunnyside Farm Shop is today. The old photograph shows Chris Brown's great grandfather setting off for market in 1911 with a cartload of cauliflowers and rhubarb. The new photograph shows their extensive nursery on Corban Lane today.

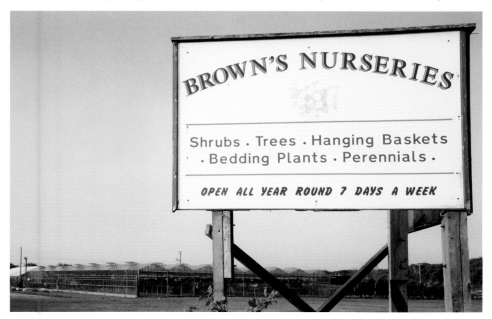

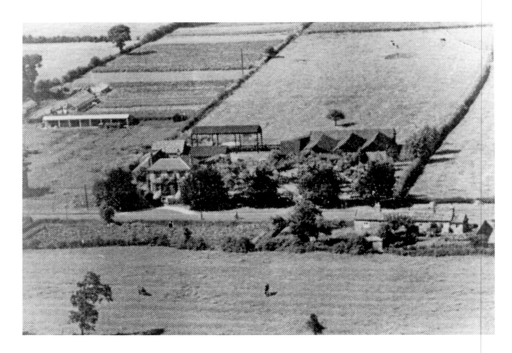

Jack Gates, butcher

This photograph, taken around 1930 shows Jack Gates' butchers and house on Mill Lane with the white-roofed pig sties top left; the other buildings housed the pigs and cattle before slaughter and then sale in the shop. Brown's original nurseries were to the left of the sties; around that time Mr and Mrs Brown lived in a railway carriage on the site of their future house. The cottages on the other side of the road to the right were demolished in the '60s to make way for the elderly peoples' bungalows there today; the land in the foreground is now Westfield Grove. The new photograph shows the Sunnyside farm shop and house which opened in 2009.

CHAPTER 2

Strensall

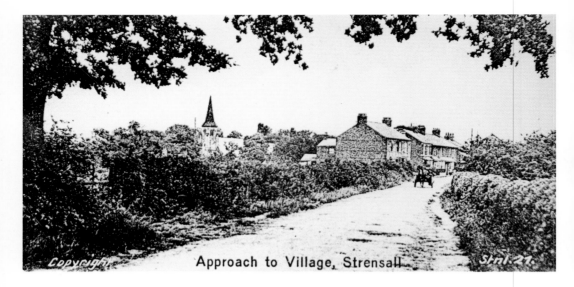

Approach to Village, Strensall

Coming in to Strensall

Taken at the end of the nineteenth century, this photograph shows that the horse and cart leaving the village was already in open country on the way to Haxby or Wigginton. Today, as the new photograph shows, there are houses to the right and Robert Wilkinson Primary School on the left. Early records tell us that of the 2,908 acres 804 were at one point given over to arable land (mainly for corn and potatoes), that many of the inhabitants worked at the tannery and that in the nineteenth century the other industry was pottery, there being two potteries in the village (Strensall and Britannia). *Baines's Directory* of 1823 has eleven farmers or yeomen out of a listing of twenty-six gentry, tradesmen, retailers and farmers while *Bulmer's 1890 Directory* has twenty-three farmers out of a total listing of fifty-nine tradesmen and professionals.

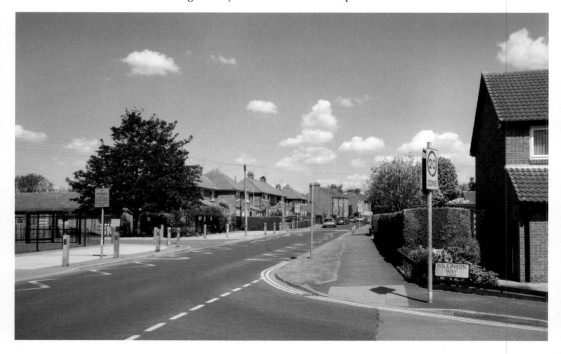

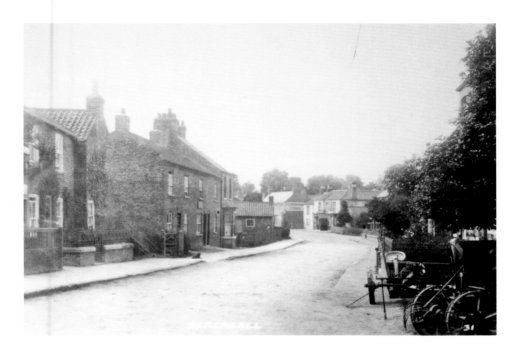

Looking down The Village in the 1920s

Looking towards the Sheriff Hutton junction with the Ship Inn (built 1819) on the right. There's a blacksmith on the immediate right with some of his repairs parked outside the forge. Creaser's – one of the three village stores – is visible beyond The Ship. The small house on the left was one of the five Poor Houses – now demolished and replaced by the ubiquitous Tesco on the new photograph. The Ship was a popular watering hole for travellers on the Foss Navigation and workers at the tannery behind. Another grocer's, Hodgson's, was over the road from where the newer photograph was taken.

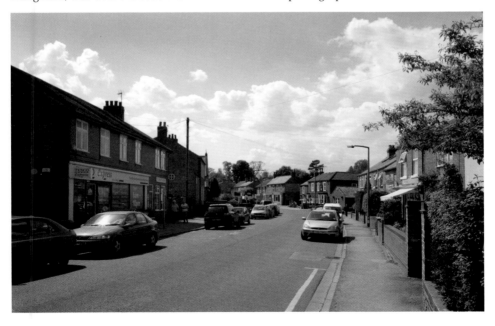

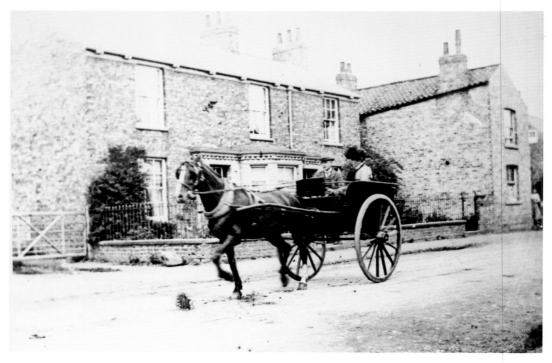

Doctor in a Trap

Dr Haslam and lady around 1910 in their pony and trap on their way out somewhere. Soon after this photograph was taken Dr Haslam swapped the trap for a car – one of the first in Strensall. His surgery was on Station Road and he practiced under the title of Physician, Surgeon and Public Vaccinator.

Today the modern picture shows the village has a twelve-doctor practice in Southlands with six practice, eight community nurses and other health professionals serving 17,000 patients from Strensall, Huntington, Dunnington and Stamford Bridge. The practice has evolved out of a single-handed practice which opened in the 1930 and now covers an area of about 200 sq. miles.

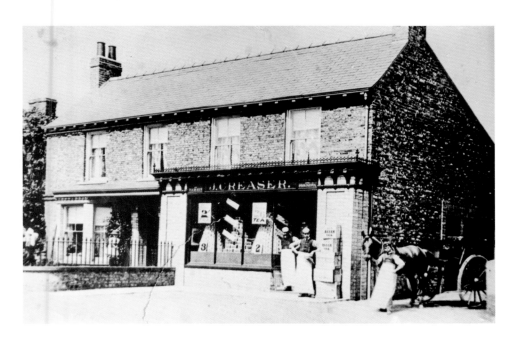

Creaser's

Three of the staff posing with the delivery horse and cart around 1880. Today, the site is occupied by Strensall Library. York Cooperative Society later took over the premises after Creaser's. As in Haxby, the petty court session reports illustrate the dependence on agriculture:

"*William Carr of Strensall, woodman v Henry Dowker, gentleman. Illegally shooting over Towthorpe Common 1 Apr 1837.*"

"*John Blanchard, gentleman v William Bosomworth, cabinet maker, both of Strensall. Trespassing in pursuit of game 3 Jun 1837.*"

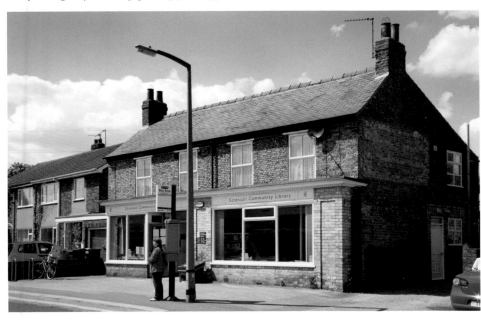

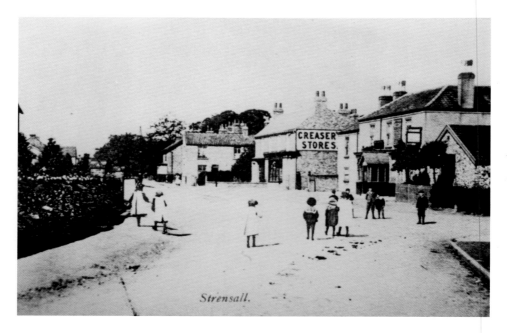

Strensall.

Playing in the Street

Taken at the turn of the century when the main road was still relatively safe to play in. The boys are wearing the sailor suits very fashionable at the time. The Ship Inn and Creaser's are clearly visible; the pub named through its association with the Foss Navigation nearby. James Green was the landlord in 1890. The Navigation brought much trade to the immediate area and fostered local business; this in turn had a marked effect on the population in the years after it opened in 1797. In 1801 the population was 297; in 1811 494; in 1901, 581; in 2001, 3,815.

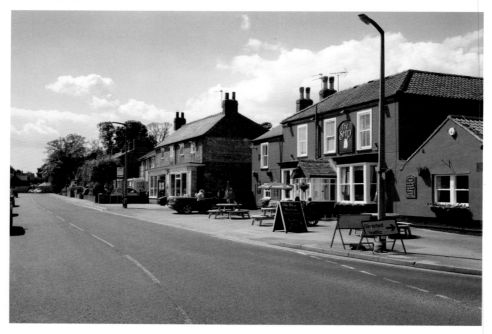

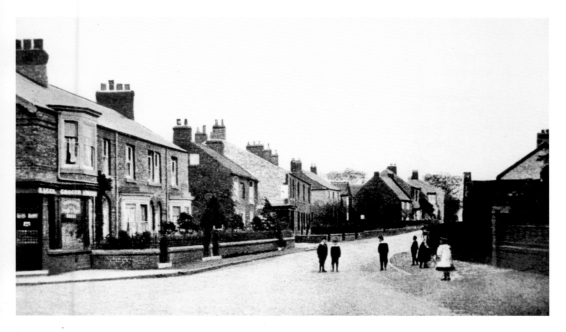

Sheriff Hutton junction

Taken about 1910 this shows Leek's, the other village store and more children wandering around nonchalantly in the road. Note the Cadbury Cocoa advert in the window. Today the building is occupied by a branch of Boots as the new picture clearly shows. On the left of the Sheriff Hutton road around 1850 were Poor Houses at Goldsmith Closes owned by the Trustees of the Poor while further on near the road junction leading to Sutton on the Forest was a tile and brickworks; we know that pancheons (earthenware bowls) were shipped down the Foss Navigation to York in 1846.

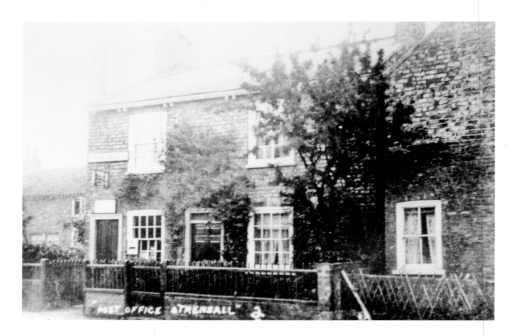

The Post Office

In the 1930s at what is now 155 The Village and occupying part of an eighteenth-century house. The modern picture shows the left-hand doorway to have been bricked up – surplus to requirements when it became a private house again. Today's Post Office is over the road from here (see page 39), moving there in the 1940s into a building which had been a grocer's since 1891. The Croft family were the last to run the post office in the old building, staying on there to run a stationery shop for some years. The girls with the skipping ropes on page 39 were Edie Palister, Jessie Frost and Minnie Belt.

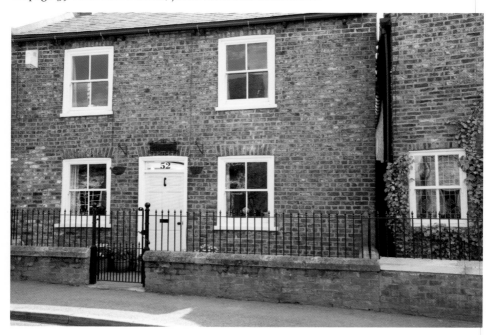

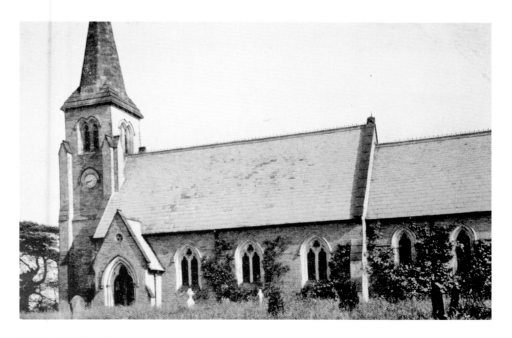

St Mary's Church

The first church here was Norman, completed in 1150. Made from Tadcaster stone it was unflatteringly described as "rude and massive" with oak pews. Rebuilt in 1801 it failed to impress the then vicar, the Rev John Hodgkinson who found it "entirely wanting in architectural or ecclesiastical style." He got his chance to remedy when he was heavily involved in another rebuilding in 1863. Sir Gilbert Scott designed what is the present church in the Early Decorated style costing £1523 12s 6d raised by subscription. A new vestry and floor were added in 1974.

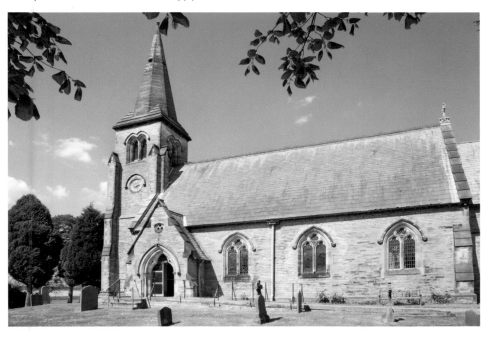

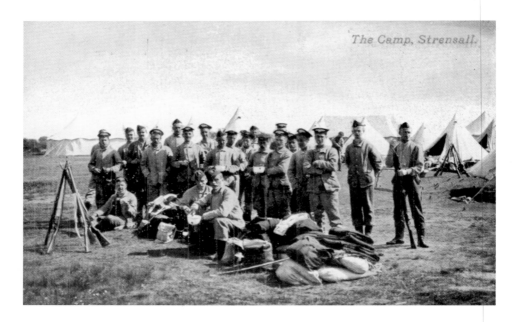

The Camp, Strensall.

Blowing up your Trumpet

Strensall's association with the Army began in 1876 when parts of Common and Lord's Moor were bought for military training for £300,000. Initially it was a camp for about 8,000 men living under canvas until the present permanent buildings were erected in 1880. A number of soldiers died from bronchitis and pneumonia as a result of the cold and damp conditions. The rifle ranges (part of which can be seen in the contemporary shot) were set up at a cost of £3,800. The commandant in 1890 was Major General N. Stevenson. Today 160-170 thousand troops pass through the barracks and the adjacent firing ranges every year on various training activites. The IRA detonated a bomb under a barrack hut here in the 1970s; fortunately it was unoccupied at the time and the terrorists succeeded in only blowing up the instruments of the army band.

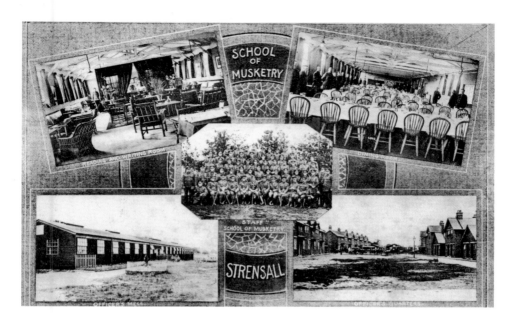

The School of Musketry

Some interesting views of the musketry training school in the early twentieth century. Known since 1929 as The Small Arms School Corps (SASC) this unit trains soldiers in the proficient use of small arms, support weapons and range management – functions still very important at Strensall although the SASC is based now in Warminster. The impact of the Camp on the village was obviously significant. *Bulmer's Directory of 1890* lists the following local professionals, tradesmen and companies directly associated with the military: *Armstrong & Sons, Army contractors; George Bowles, camp coffee house; R.P. Culley & Co, Army contractors and messmen to camp stores; Rev. J.B. Draper, acting chaplain; William B. Cunliffe, photographic artist, Strensall Camp; William Taylor, camp livery stables; Richard Tinson, camp postman.*

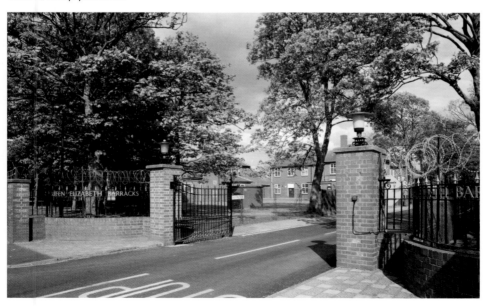

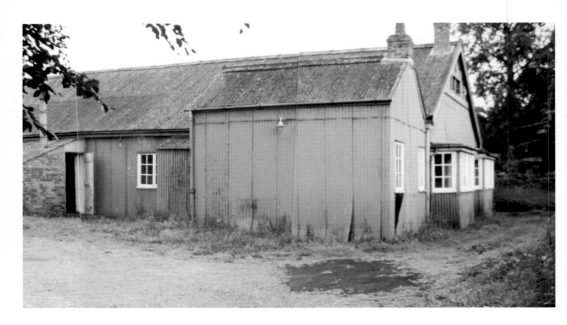

The Suez Canal Village Hall

Originally an army hut on the banks of the Suez Canal this amazingly resilient building was painstakingly taken to bits and shipped back to Strensall from Egypt in 1920; once rebuilt it provided the village with its popular social venue for the next sixty years. It was demolished in 1980 and replaced by a house at 9 York Road ("Woodhurst"). The new village hall is in Northfields as shown in today's photograph – highly functional, architecturally challenged, although it must be said that it does bear a vague resemblance to the old Egyptian hut. It was built in 1989 at a cost of £209,000.

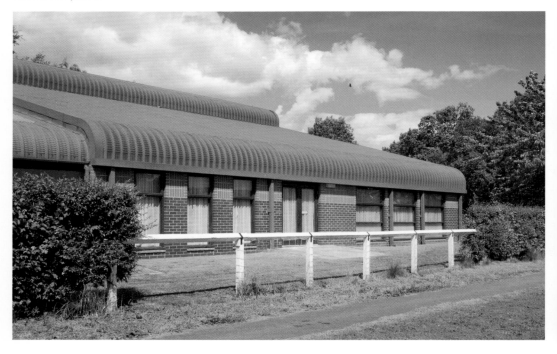

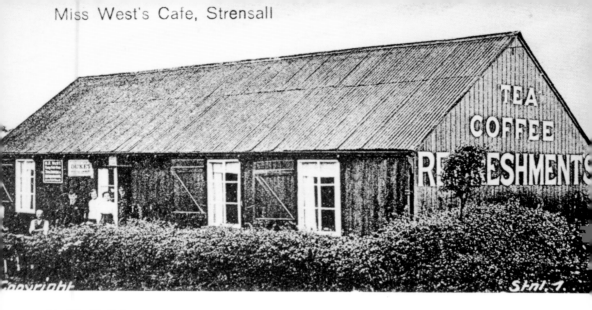

Miss West's Cafe, Strensall

Ma West's Cafe

This was set up as a kind of social centre for the soldiers from Queen Elizabeth Barracks opposite; it provided a change for anyone who may have wanted to escape from mess life and go somewhere to get a cup of tea, perhaps, in a more relaxed environment. It followed the tradition of a colonel's widow who set up a small cafe in a tent nearby in the 1880s for the troops. As its popularity grew the tent was replaced by a series of ever larger wooden huts. No alcohol was permitted and temperance type lectures were given in the evenings. A twenty-first century equivalent of sorts, a Chinese take-away, now occupies the site.

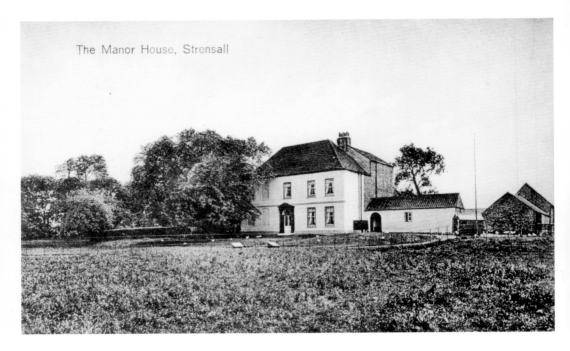

The Manor House, Strensall

Manor House

Also known as The Hall, this was lived in in 1851 by a seventy-year-old widowed farmer, John Creser (ancestor of the grocer's?) with his two daughters (Mary and Maria) and two sons (Matthew and George). The house came with sixty-one acres of land, twenty-three of which were pasture, thirty-seven arable. The original manor house was moated and dated from 1649, rebuilt in 1757. There was a smithy nearby in Coney Garths; other streets thereabouts included Hall Inge, Pudding Park, Palling, Butt Close and Long Wall Butt.

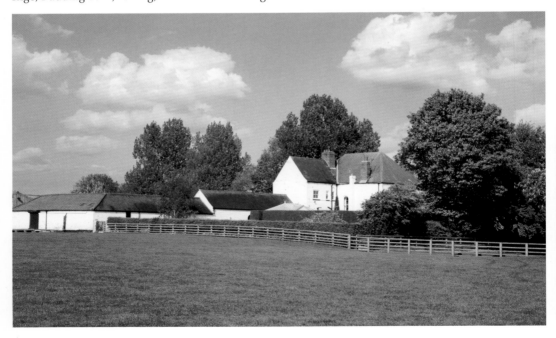

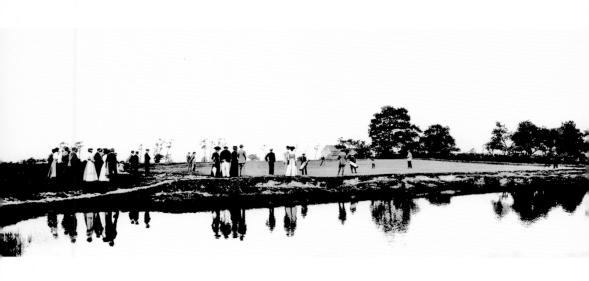

"Constitutionally and physically, women are unfitted for golf."
This intriguing photograph is by the celebrated Edwardian photographer Alfred Hind Robinson (1864-1959) - one of the pioneers of panoramic photography who shot over 2,000 panoramas between 1903 and 1930. It gives some idea of the importance of the Club as a social hub in York and the gentility associated with it. It is unlikely that women were in the early days really encouraged at the club, if these quotations are anything to go by:

"If they choose to play when the men are feeding or resting, no one can object; but at other times – must we say it ? – they are in the way."

On mixed golf: *"It's all very pleasant, but it's not business."* *"Women are bound to fall out and quarrel on the slightest, or no, provocation."*

And the final, damning verdict: *"Constitutionally and physically, women are unfitted for golf".*

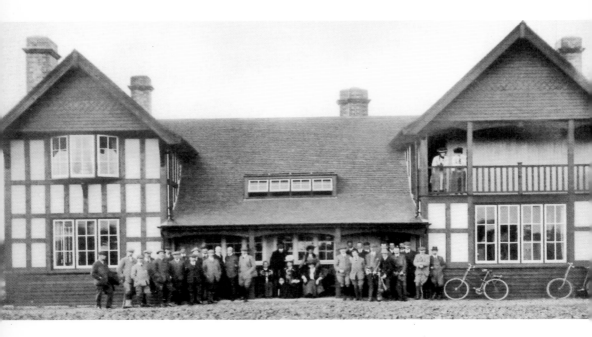

The Old Clubhouse opens

The original clubhouse was built in 1907; this splendid photograph shows the opening ceremony on 17 May with Sir Leslie Rundle doing the honours. York Golf Club had been founded in 1890 and was originally at the Knavesmire. The fact that it was public land caused problems as cows, horses and other livestock grazed on land that was also frequented by nursemaids with their perambulators. One of the early club rules was indicative of the hazards: "Members are to refrain from striking while people or cattle are in the way." To avoid accidents to man and beast the Club moved to what was army land in Strensall in 1904.

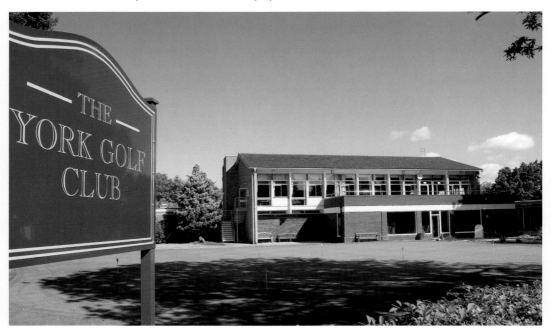

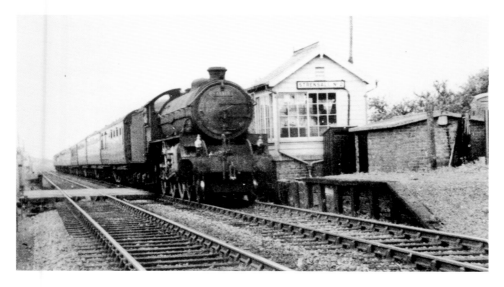

"Mak all t' trains cum t' York."

The first train to pass through Strensall was on 7 July 1845 travelling from York to Scarborough via Haxby. George Hudson, Railway King, was on board – no doubt very proud as it was he who had urged Robert Stephenson to "mak all t' trains cum t' York." That famous day ended with dinner for 700 in York. Close to the station was the now demolished brick works (the Littlethorpe Brick and Tile Company) from which millions of bricks were shipped by rail. As with all change, the railways had its detractors, particularly at the Scarborough end where the concern was that *"a great influx of vagrants and those who had no money to spend"* would ruin the resort. *"The novelty of not having a railway will be (Scarborough's) greatest recommendation."* This old photograph is from 1914; as in Haxby the station closed in 1930 but was re-opened for military use in the Second World War. Three trains a day passed through the village on the way to Scarborough and back to York in 1945. The fare from York to Strensall was 6d in 1884. The new photograph shows a somewhat less romantic modern train passing the other crossing at Breck's Lane.

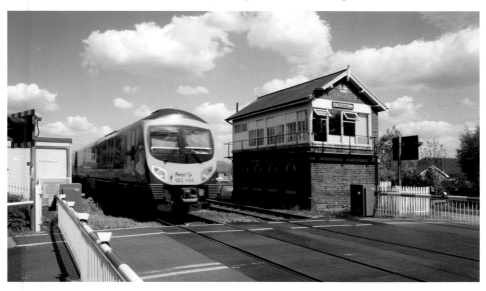

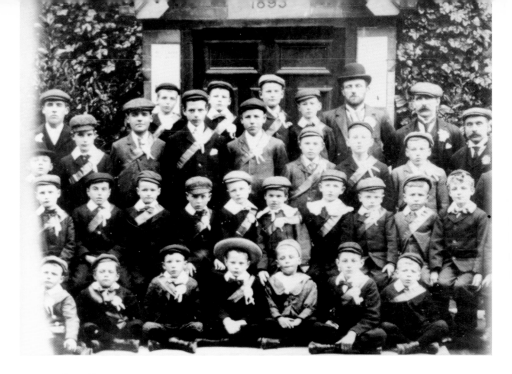

St Mary's Hall

The old Methodist Chapel in Church Lane built in 1823. Scrubbed up and in Sunday best this Sunday school class look all look a bit glum. A new (the present) chapel was built in The Village in 1895 as the congregation had outgrown this one, although the old chapel was still in use until 1921 for special events. The railway continued to exert an influence on the village: there was a restaurant in the station by 1905 and mail was delivered twice daily at 6.00 am and 3.50 pm. There was a post office at the camp as well as the one in the village; soldiers also benefitted from a Money & Telegraph Savings Office and an Annuity and Insurance Office. The new photograph shows the somewhat dilapidated but brightly painted chapel today.

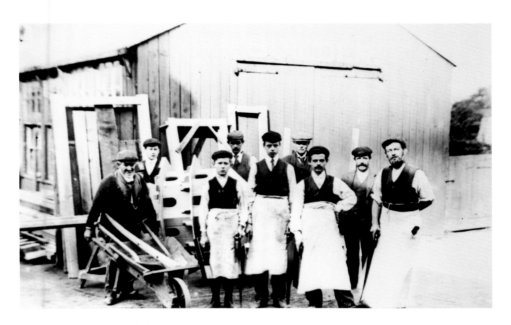

The Joiner's Shop and the Tannery

Carpenters posing during a job in the village, possibly connected with local agriculture or with construction. The modern photograph shows what remains of another of Strensall's industries: tanning. Opened in 1806 as Hirst & Sons the tannery was able to benefit from the Foss Navigation which had opened as far as Strensall in 1797, with the extension to Sheriff Hutton Bridge begun in 1801. The Navigation passed conveniently nearby for the delivery of materials such as bark and lime and the despatch of finished goods. *Baines Directory 1890* lists three boot and shoemakers (including another Creaser) and a tanner, William Walker, at the tannery ("oak bark tanners of shaved and dressed hides"). Later owned by Leeds tanners Charles F. Stead & Co it employed fifty or so people in the 1960s. By the time it closed in 2004 only nine workers remained; since then it has remained derelict and half-demolished.

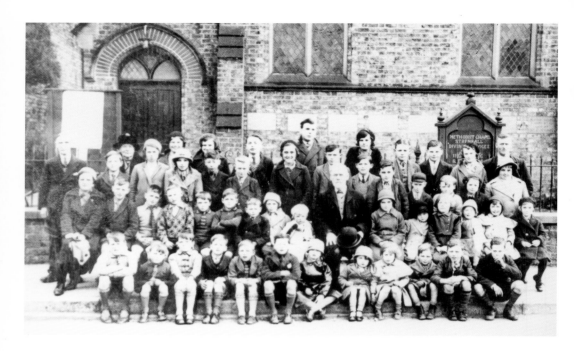

Sunday School 1934

The Methodist Sunday School. William Warner was a preacher there and went on to become one of the first Methodist preachers to take the faith to the West Indies. The area's only Victoria Cross was a pupil at Stensall school around 1900: Lance Sgt Harry Wood served in the 2nd Battalion Scots Guards and won the Military Medal in 1914 for showing 'true grit' in Belgium; in October 1918 he demonstrated amazing bravery when his unit cleared the village of St Python in the allies' final push of the war and was awarded the VC.

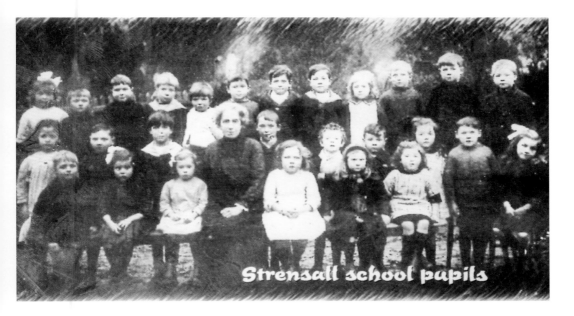

Strensall school pupils

Robert Wilkinson VC Primary School

The first school was a thatched cottage built in 1718 from an endowment left by local farmer Robert Wilkinson in his will. This paid the schoolmaster's wages; five pupils were on the roll. A larger school was built in 1807 then demolished in 1857 to enable a yet larger school to be built – the Endowed National School for 93 children. The older picture shows pupils at Strensall school in Edwardian days while the newer shows a recent visit to today's school by a truly versatile Victorian gentleman: *"Year 5 experienced a visit from a Victorian teacher called Mr Cade. We sat in rows and he taught us arithmetic using slates and slate pencils to write with. Some of us were lucky because we got to use inkwells and ink pens. Later he came back as a butler from Castle Howard. He showed us some rich children's toys. There was an egg and cup, a spinning top, a Diablo and many other toys we still use today. However, he told us the life of a servant was completely different because they never had time to play and just worked, ate and slept."* by Benjamin Mould and Benjamin Brown. Note the cane ready to be deployed.

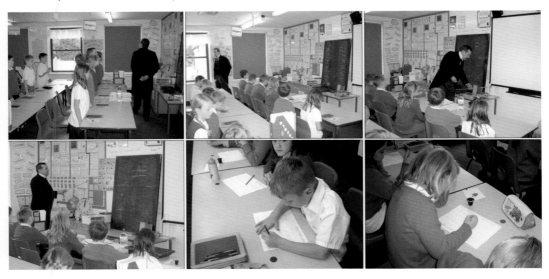

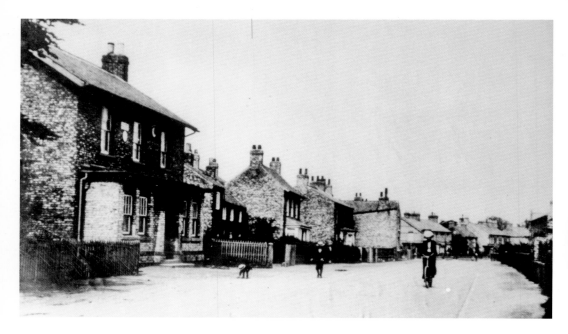

Half Moon Inn

Looking toward The Village with the Half Moon on the left. Henry Nattriss was landlord in 1890. The pub's name may reflect the old tradition where large houses (including those owned by the church as here) were often open to travellers for food and drink; signs such as a half moon would have indicated that, as in this case, the (public) house was a place of refreshment. Alternatively it may be connected with the Earl of Northumberland whose badge was a half moon; the Earl was a friend of William Poteman, Prebendary of Strensall. The existing building was rebuilt in 1830 on the site of the earlier tavern. Messers Bellerby and Jackson owned the pub in 1849. The building projecting out into the street on the left was Bellerby Square, now demolished.

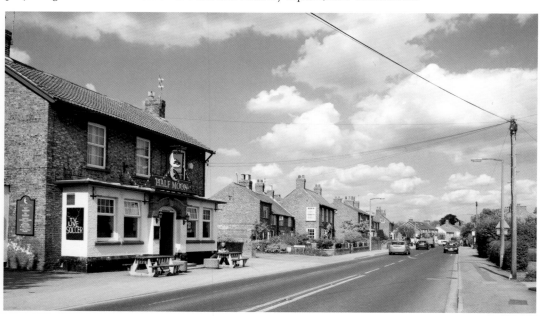

CHAPTER 3

Huntington

NEW LANE

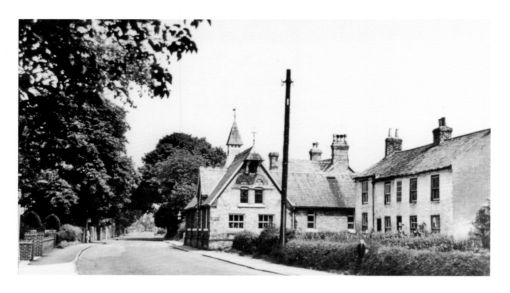

Broken bell ropes, Zeppelin raids and potato pickers

Opened in 1877 the Board School was an extension of an earlier one classroom parish school. There were forty-nine pupils on the roll and parents had to pay until 1891 when education was made free for all. Fees were 2d for infants, 4d for juniors and 6d for seniors; a fourth child went free if the others were infants. The fine for non-payment was a crippling 5s. Entries from the school day book provide an interesting, sometimes poignant, commentary on the times:

8th December 1879: School closed on account of the Scarlet Fever for 5 weeks. 25 cases have occurred one of which terminated fatally. The child that died was aged 10 – one of the brightest and best behaved in the school.

8th May 1883: The bell rope broke this morning and we are unable to summon the children to school for a day or two.

28th November 1916: The absences this morning are chiefly due to the Zeppelin Raid last night.

8th November 1918: Nearly 50% of the children are absent, picking potatoes.

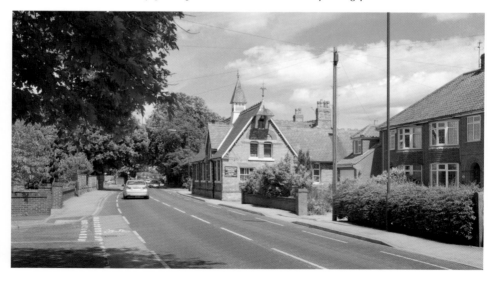

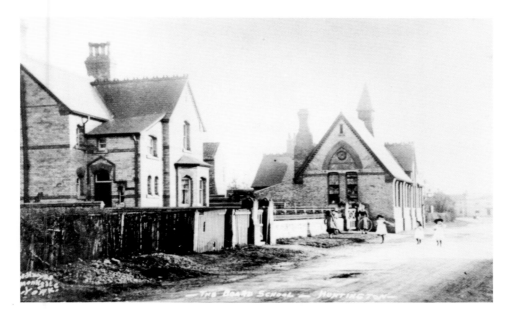

The Board School and the Memorial Hall

By the 1920s the growing number of pupils necessitated the use of the Memorial Hall (see new photograph) in Strensall Road (built in 1921) until the older pupils moved to Joseph Rowntree School in 1941. The Hall was built by local men back from the war who gave their services free. They used bricks from Wray's Brickyard, where Birch Park is now. There is a Roll of Honour in the entrance for the dead, injured and those taken prisoner. Huntington lost thirty men in the 1914-1918 war and twenty-six in the Second World War. Huntington's population in 1801 was 312, by 1901 it had doubled to 631; in 1961 it had grown to 5,681 thus necessitating a new junior school. This duly opened in 1962 in North Moor Road with 260 pupils on the roll.

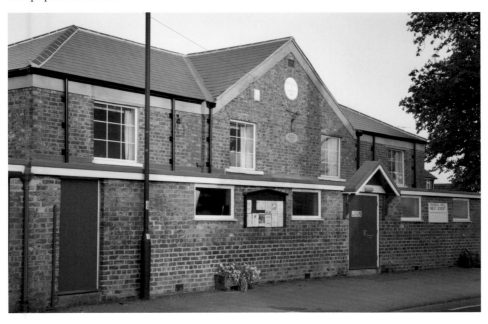

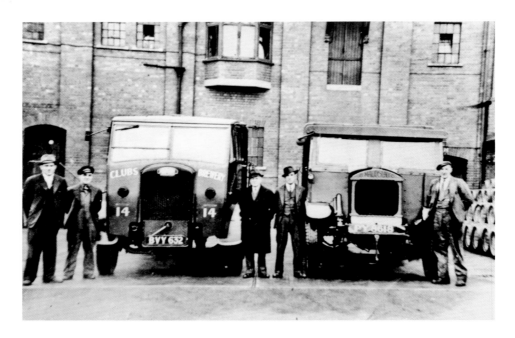

Outside the Yorkshire Clubs Brewery, New Lane

The Loco Brewery moved from Chapmangate, Pocklington in 1934 into a purpose built factory in New Lane. Up to fifty workers were employed, some of whom were housed in Brewery Cottages, which survive to this day along with the iron railings which were in front of the brewery building. The brewery vehicles photographed here during the Second World War have had their headlamps masked (so that they could not be seen) and mudguards painted white (so that they could be seen) in the blackout. The brewery closed in 1968 and was demolished in 1973. Note the personalised license plate on the left hand truck? The new photograph shows Brewery Cottages today.

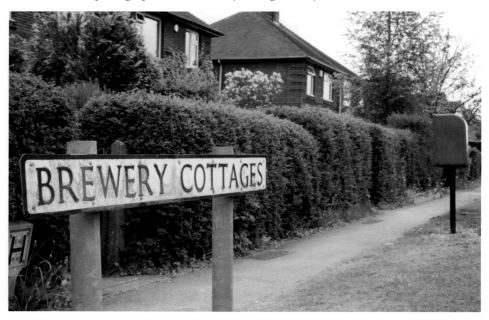

Butter Cross in Church Lane

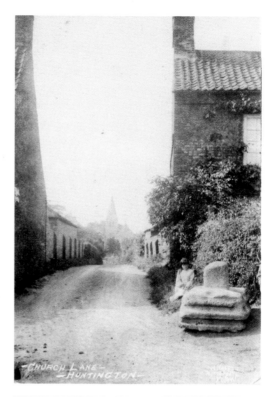

The butter cross is a type of market cross dating from medieval times. Its name tell us that they indicated the place in the market where people from the surrounding area would come to buy locally produced butter, milk and eggs. The dairy produce was displayed on the circular stepped bases of the cross.

The house on the right was badly damaged when a Wellington bomber crashed on the houses opposite the Blacksmith's Arms on the afternoon of 14 April 1943. The MK10 Wellington was from 429 Squadron, Royal Air Force based at Eastmoor and on a training flight when an engine fire caused it to crash. The pilot and four other crew were killed along with three ladies on the ground; the cottages were rebuilt with one of them appropriately named 'Phoenix'.

The church in the modern photograph is all but obscured by trees. Six of the eight bells were donated by the Mills family around 1881, one of whom had expressed a wish to be buried there; each member of the family provided a bell in payment. The church was restored in 1874; when the wooden steeple was replaced two stones of honey were found up there. Tether rings for worshippers' horses can still be seen by the entrance.

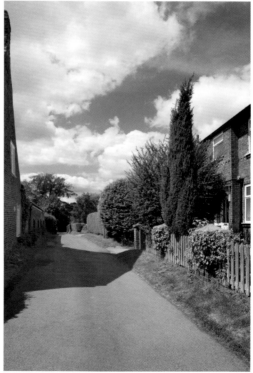

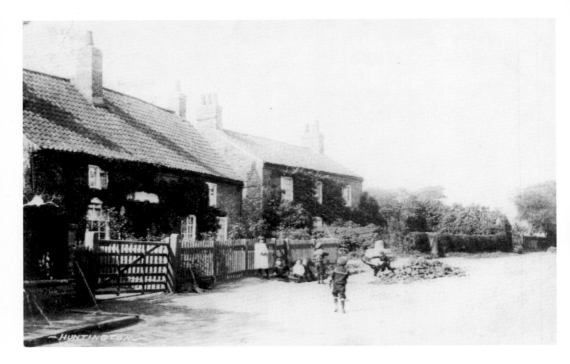

Clock Cottage

The cottage on the left was once the post office; it gets its name from the clock that was placed on the wall there in 1893 and which can be seen clearly on today's shot. It cost £8 10*s*, raised by public subscription. In 1953 an early seventeenth century inglenook fireplace was discovered in the cottage by a builder carrying out alterations. It was subsequently restored to its original condition and left *in situ*.

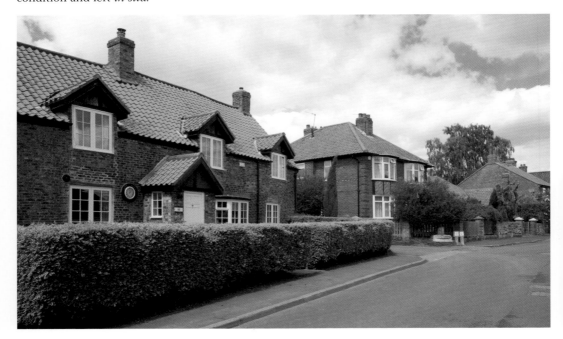

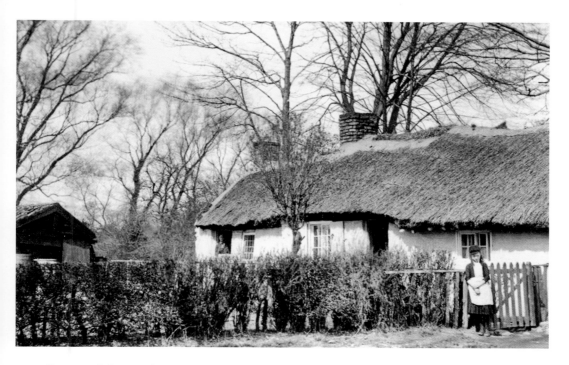

"An act of the very immoral conduct"

These cottages were at the York end of Old Village. William Bowl and Francis Lonsdale lived there in 1843 when they were served notice to pay rent arrears within one month; in 1845 records tell us that an "act of the very immoral conduct" was perpetrated in the house and led to the tenants' eviction. A bill for thatching in 1847 came to 13s 3d. In 1907 one of the cottages collapsed; Mrs Plowman and her two daughters were in at the time and had to escape through a window.

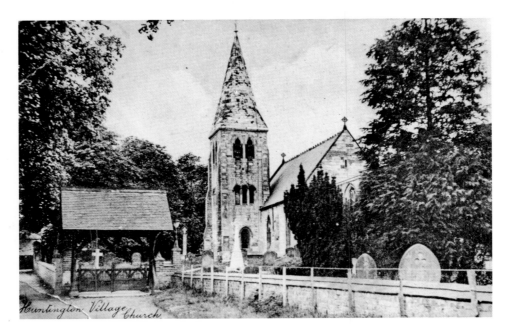

Huntington Village Church

All Saints' Church and a royal pardon

"Nigel has a church and a priest" Domesday tells us. Nigel was Nigel Fossard who was Lord of the Manor in Huntington. The original church is thus dateable to before 1080. All Saints' was the setting for a royal pardon during the reign of Edward III: Cicely, wife of William Clere of Haxby was convicted with her husband of breaking and entering the church and of *"divers larcenies there and at Haxby"*; but *"because Cicely was with child, her execution was deferred, and in 1345 the king, moved by pity and at the supplication of Queen Philippa, pardoned her"*. As can be seen from the contemporary photo, the fine lych-gate from 1877 has now been removed.

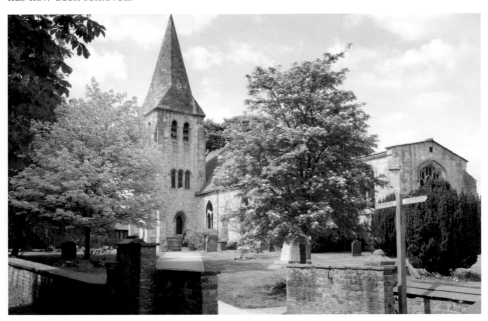

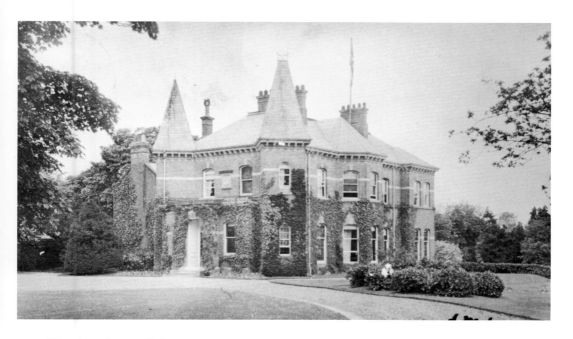

West Huntington Hall

Sir Arthur Ingram had this built in 1629; it was restored in 1800 by Captain Sir Thomas Dowker. Other owners have included Dowager Lady Austin in 1909; Ethel Newton, local artist from 1914; the Army Kinema Corporation in 1948 (an organisation based in Croydon, responsible for providing the British army wherever it was in the world with film entertainment); and Peter Gray, a dentist, in 1960. Dowker's daughter, Rosamund, married Lord Allan Spencer Churchill, third son of the Duke of Marlborough in July 1846. A true gallant, Churchill, stationed at York cavalry barracks, when visiting her once before they were married, couldn't get over the Foss as the bridge was broken; so, he borrowed a washing trough from one of the cottages next to the Blacksmith's Arms and rowed across to his fiancée.

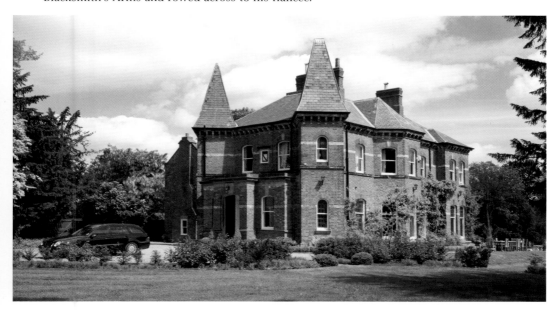

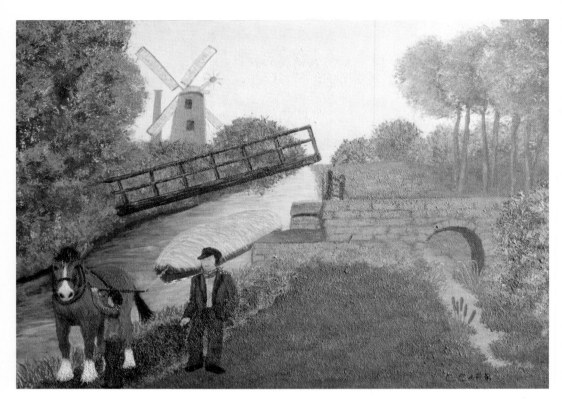

Dowker's Swing Bridge/Barge Passing Through Dowker's Mill
Named after Captain Dowker this swing bridge at the foot of Mill Hill was built around 1800 to allow barges to pass through on the Foss. The barges, crewed by one man and a boy, were pulled either by a horse or gangs of men called halers. See page 57. The painting is by Carol Carr. The new photograph shows the bridge over the Foss at Church Lane.

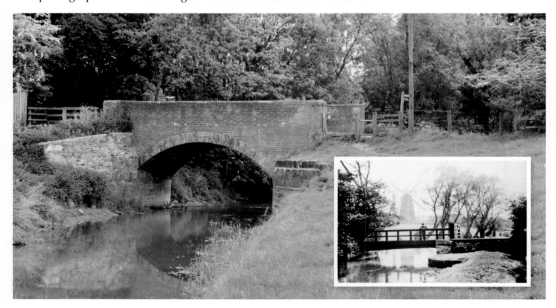

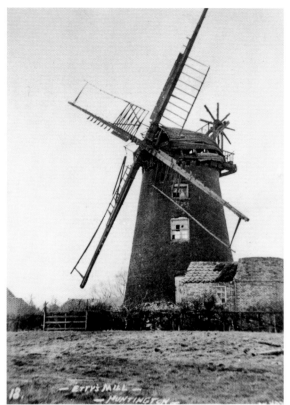

The Corn Mill

Situated at the highest point of the village, Hoggard's Hill (Mill Hill) ceased operations in 1900, thus bringing to an end 700 years of milling on the site. It was also called Etty's Mill after Charles Matthew Etty, miller there from 1890-1897 and relative of William Etty the celebrated York painter. The bricks from the demolished mill were used to build Mill House nearby.

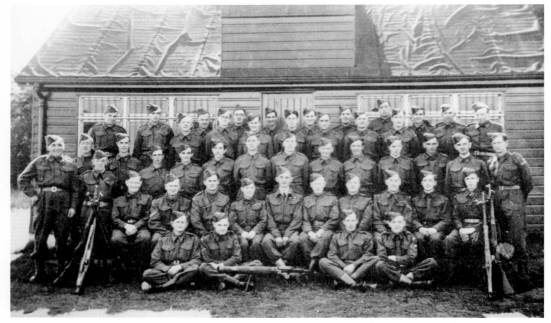

Home Guard

Recruited from Huntington and New Earswick their HQ was in West Huntington Hall's coach house. They wore the cap badge of the Green Howard's and their commanding officer was a Captain Palmer, a former Royal Engineer who rode on horseback, his rifle in a leather holder strapped to his saddle. This photograph was taken on the sports field in front of Joseph Rowntree School. As in Haxby, refugees from Hull and Middlesborough were housed in Huntington. Today's picture shows the War Memorial in the grounds of All Saints Church which commemorates thirty men fallen in the First World War and twenty-six in the Second World War.

CHAPTER 4

New Earswick

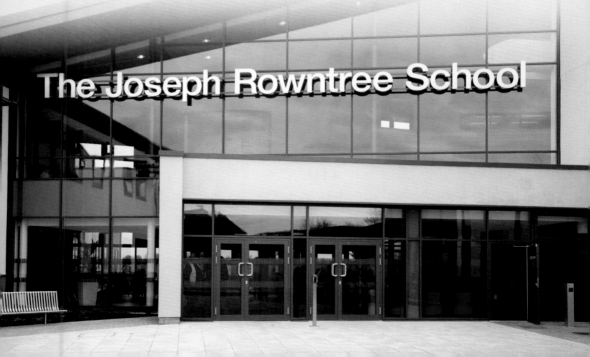

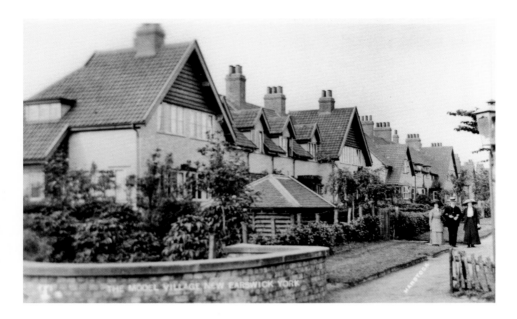

Station Avenue

The objective of the Joseph Rowntree Trust when it developed the idea of the new garden village was to provide the worker with even the lowest means a new type of house that was clean, sanitary and efficient. Rowntree's deep concern for the welfare of his workers, the research findings of his son, Seebohm, into the plight of the urban poor, his Quaker beliefs and the pioneering work on garden cities by Ebenezer Howard all combined to drive Rowntree's New Earswick. This photograph shows Station Avenue from the Folk Hall complete with garden pumping station – now sunk underground as the new photograph shows. These houses were in groups of seven with an access tunnel between the third and fourth houses. They cost £318 7s 11d to build; rent was 6s 3d per week. The Second World War Morrison air raid shelter was in Station Avenue.

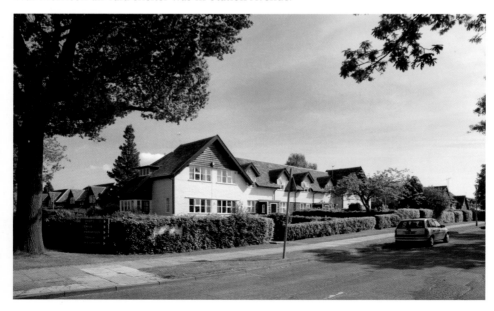

Western Terrace water pump

In Western Terrace in 1908; the houses opposite are in Poplar Grove whose gardens run down to the River Foss. As can be seen, they were built in groups of four. The architect of the New Earswick houses and the Folk Hall was Raymond Unwin whose brief from the Trust was nothing if not challenging: to provide high quality housing at affordable rents with adequate living space within restricted floor space. The houses did not all front on to the street as the living room was always situated where it could get maximum sunlight. The building programme was as follows: 1902 – 123 houses; 1902-1904 – 28; 1904-1919 – 229; 1919-1936 – 259. Total spend on land, houses and services was £450,000.

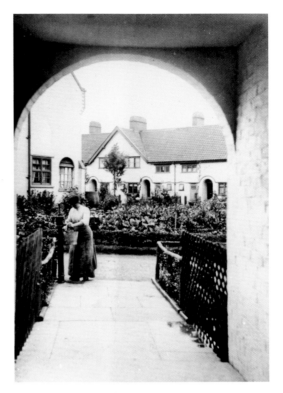

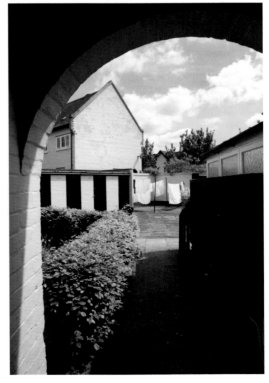

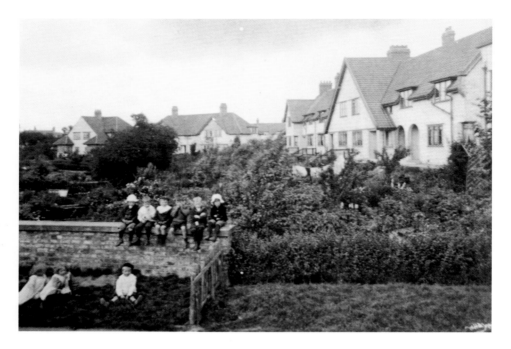

Western Terrace

Western Terrace about 1906. To meet his brief Unwin used some of the indoor floor space as a bicycle store and a coal store, obviating the need for outhouses and thus reducing costs and allowing upstairs space for a third bedroom. The toilet was downstairs and the bath was in the kitchen under a hinged table flap. A black range was in the living room with a pantry. The first houses had earth closets which were replaced in 1906 with a water system. In 1948 93% of the 530 houses had 3 bedrooms; 1 had 2 and the rest 4 or 5. Separate bathrooms came in 30 new houses built in 1954.

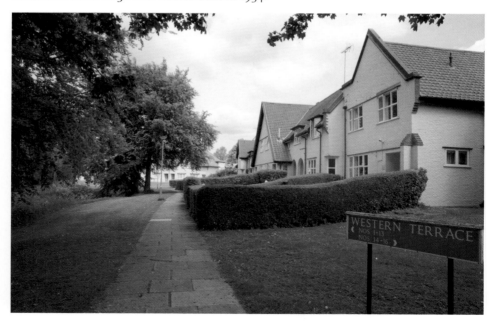

Hawthorne Terrace

Hawthorn Terrace – here the three bedroom houses cost £422 16s 0d to build and the weekly rent was 7s 9d. Floors in New Earswick were typically lino and red quarry tiles; taps and door knobs were all brass. The twelve bungalows for older residents featured a large room which could be used as a living room/bedroom or as two separate rooms (with obvious social and financial benefits on heating costs); in addition they were fitted with alarm bells for emergencies, connected to a qualified nurses' rent-free residence. All evidence that, socially and environmentally, New Earswick was years ahead of its time. The older picture shows how New Earswick was part of a national garden city movement at the time with pictures here from Letchworth, Bournville and Hampstead.

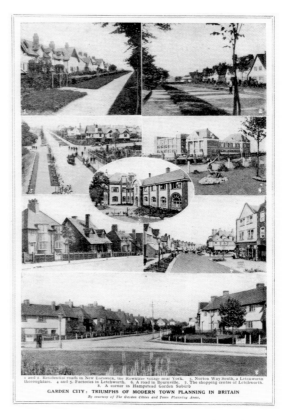

1 and 2. Residential roads in New Earswick, the Rowntree village near York. 3. Norton Way South, a Letchworth thoroughfare. 4 and 5. Factories in Letchworth. 6. A road in Bournville. 7. The shopping centre of Letchworth. 8. A corner in Hampstead Garden Suburb.

GARDEN CITY: TRIUMPHS OF MODERN TOWN PLANNING IN BRITAIN
By courtesy of The Garden Cities and Town Planning Assoc.

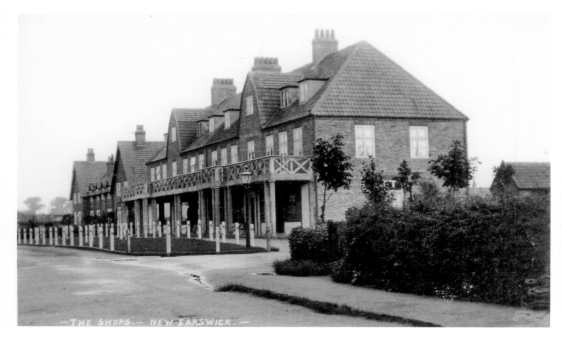

Hawthorne Terrace shops

Note the ornate balconies, now removed, and the mansard gables on the flats above the shops; these allowed more internal headroom in the flats. Once a year on 1 June a barrier was lowered at Station Avenue to enforce the legal privacy of access as all the roads were private and a 1*d* toll was paid by vehicles passing through. Shops in the '30s included Howard's haberdashery, Mrs Farrell's sweet shop, Ernie Wood's chemist, Fred Wiley the cobbler, the Co-op butchers, Burrell's bakers and Coning's wet fish shop.

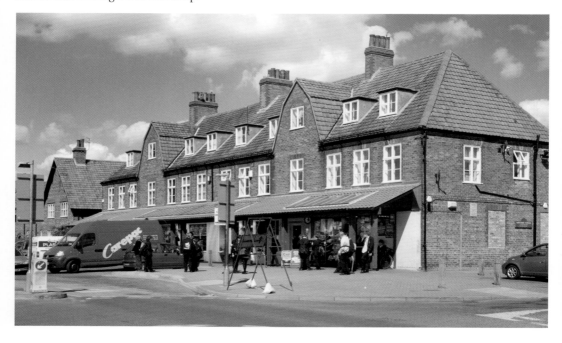

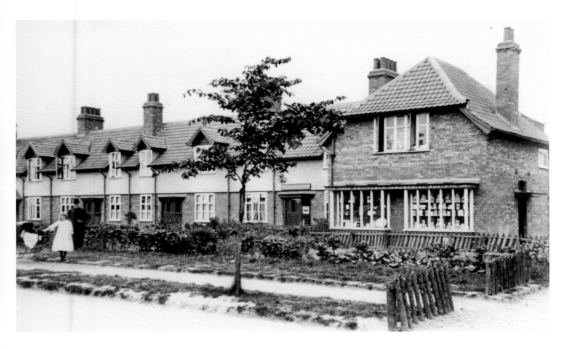

York Equitable Industrial Society

This Edwardian photograph shows the Co-op in Station Avenue on the right (see page 10). It was the first shop to be built in the village in 1908, with the original post office next door. Provisions continued to be delivered by horse and cart though, despite the emergence of more and more shops: milk twice a day at 7.00 am and 4.00 pm from Crompton farm and from Sorenson's (see p.82); vegetable and fish. Today the building houses a bakery as the new picture shows.

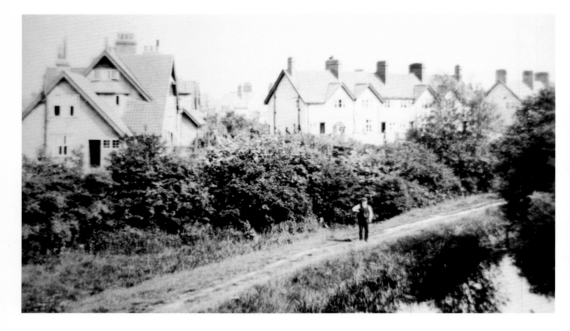

River Foss and the Foss Navigation

Mr Bewer, crossing keeper, takes a stroll along the banks of the River Foss in between trains; the houses are in Willow Bank and face out to give a pleasant river view. The Foss was canalised by the Foss Navigation Company as far as the bridge at Sheriff Hutton in 1806, a thriving town then. It cost £35,000; 1809 provided the best toll receipts: £1,384. The horses that hauled the barges could manage a weight of 27 tons given a favourable current; the same horse could cope with only 1 ton road cargo. The opening of the York to Scarborough railway through Haxby and Strensall in 1845 and the York to Hull line through Huntington in 1847 rendered the canal commercially redundant in 1852 – the first navigation to close as a result of the railways.

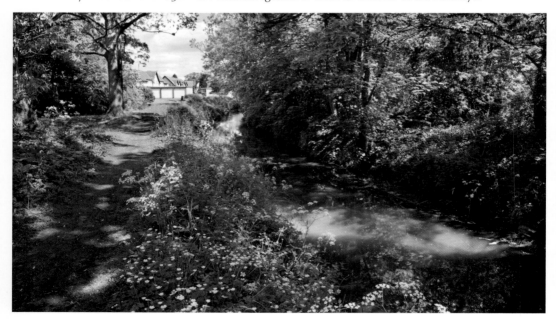

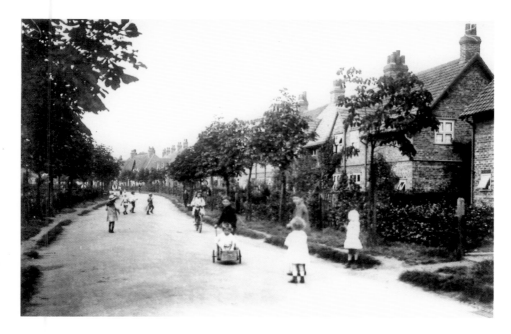

Chestnut Avenue

Built 1917-1918 in blocks of four with a central passageway for access. Chestnut Avenue then and now epitomises the ethos of the village: tree lined, virtually car free avenues which were and are pleasant to live and play in. Cost to build was £309. 15s 7d and rent was 6s per week if the bath was in the scullery; if it was upstairs it was 6s 8d. Nurse Atkinson lived in nearby Rowan Avenue. She was the village District Nurse and midwife from 1944 until her retirement in 1969 during which time she estimates that she delivered about 1,000 babies. Dr Riddols (see p.14) was village doctor and President of the Nursing Association: one of his duties was to collect the 2d per week from residents to pay for Nurse Atkinson.

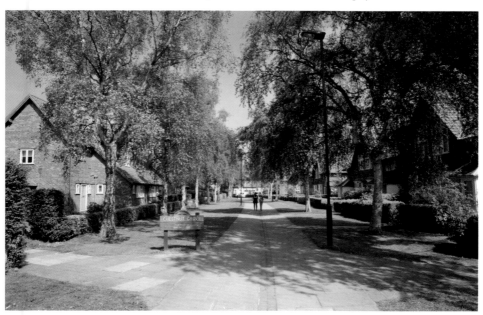

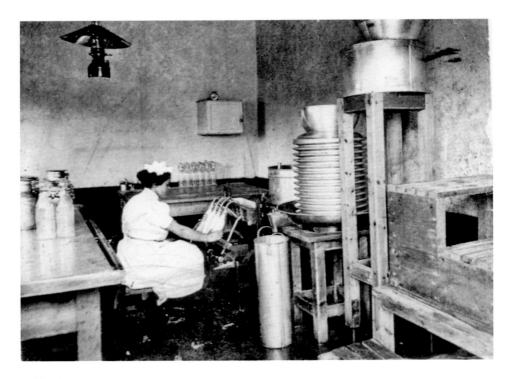

White Rose Dairy 1904

The inspiration of Seebohm Rowntree, author of the influential *Poverty: A Study of Town Life;* he established the dairy to ensure the provision of clean milk to village residents in the knowing that contaminated milk was a factor in the high infant mortality rate. To do this he brought in a Dane, Wilfred Sorensen (known locally and geographically inaccurately as Oslo), from the Manchester Pure Milk Co and bought some land for him to build a farm on and develop a herd. For the time unusually high levels of hygiene were adopted, the milk was filtered and cooled to destroy bacteria. The new Joseph Rowntree school provides an impressive background to this somewhat aloof group of cows.

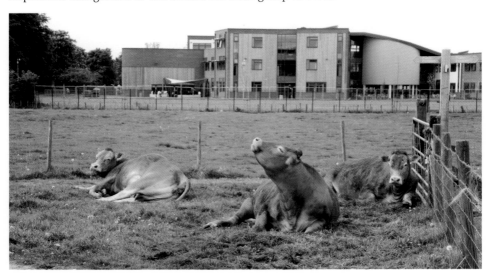

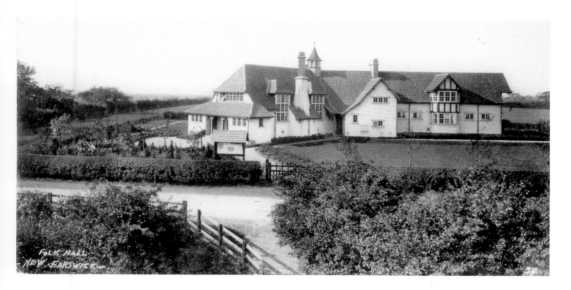

Folk Hall

Built in 1907 at a cost of £2,278 15s 1½d. Rowntree actively encouraged women to get out of the home and use the many facilities offered there: "In this country it seems to be the thought that women do not need recreation" he pondered, citing the example of Germany where it was and still is the norm for families to go out together as families, with the children. One of the functions of the Hall was as a place of worship – for all faiths. However, over time a separate Wesleyan Chapel and a place for Anglican worship were established while the Society of Friends and Roman Catholics continued to use the Hall. From 1945 it was home to the village nursery until its move to the primary school in 1997. At its opening there were thirty children between two and five each paying 1s per week, mornings only.

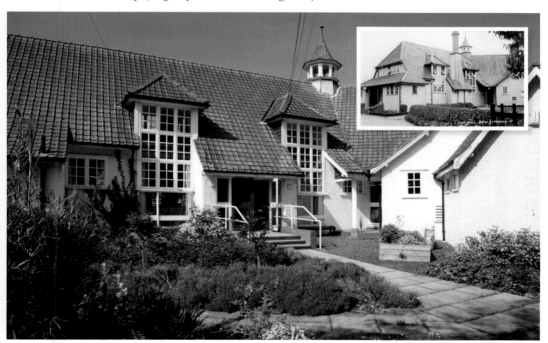

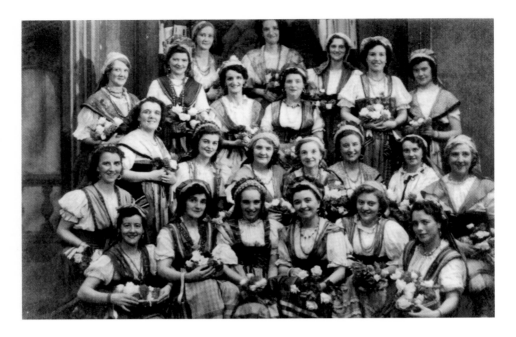

New Earswick Musical Society

The older photograph shows a NEMS production from the 30s. The society was founded in 1914 (out of the 1912 Choral Society) as the New Earswick Dramatic Society and ninety-six years later still performs two shows every year, now in the Joseph Rowntree Theatre in Haxby Road. In 1933 the Society had 260 active members and performed a staggering 24 productions – Gilbert and Sullivan plays and operas – one every two weeks. Recent repertoires are much more diverse and have included *The Railway Children, High Society, Oliver* and *Hello, Dolly!* The success of the society helped drive through a new hall with seating for 450, a well lit stage and dressing rooms in 1935. The new picture shows a recent production of Sugar, adapted from Some Like it Hot.

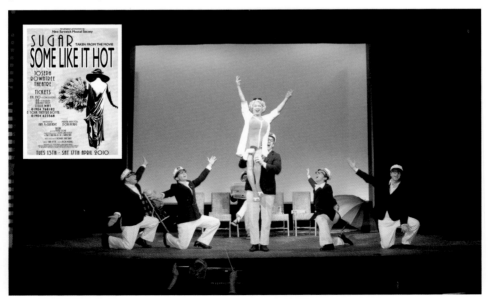

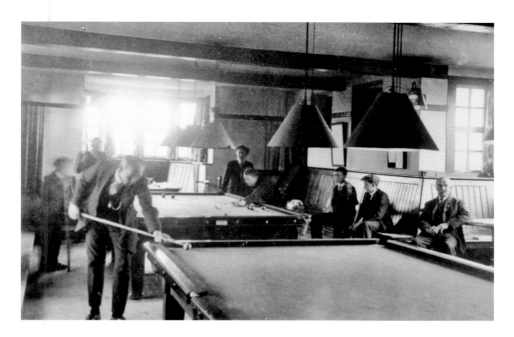

Folk Hall snooker

Snooker was one of the many social activities held in the Folk Hall – one of the main purposes of which was to offer societies and clubs a place in which to run activities, reflective of the interests of the residents. The first football club was formed in 1912 soon followed by the cricket club; initially both played on the green opposite the shops in Hawthorne Terrace but Westfield Beck proved a hazard and the shop windows provided too tempting target practice for the batsmen. By 1923 both teams were able to play on pitches at the newly developed 16 acre sports fields. There were also tennis courts and a bowling green and a sports pavilion. The many adult education courses espoused by the Rowntrees took place at the Folk Hall. Snooker is still played in the Hall, as photographer Mark Sunderland so ably demonstrates here.

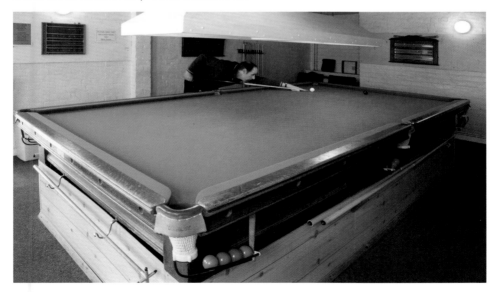

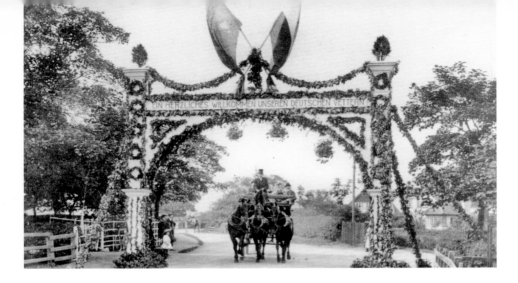

German Garden Association visits New Earswick 1909

In developing New Earswick, Joseph Rowntree was heavily influenced by Ebenezer Howard's (1850-1928) vision of a kind of utopian city where citizens lived in harmony with nature. This was described in his 1898 *Tomorrow: A Peaceful Path to Real Reform*, retitled *Garden Cities of Tomorrow* in 1902. Equal opportunity, good wages, entertainment, low rents, beauty, fresh air were the aim: factors we can recognise in Joseph Rowntree's New Earswick. Howard's humanism and progressive vision was influential in other countries too, not least in Germany where the German Garden City Association, "*unseren Deutschen Vettern*", flourished. The Association embraced Howard's vision, as evidenced by their visit here on July 7th 1909. There is, however, a sinister side to the story. Theodor Fritsch (1852-1933) claimed to be the originator of the garden city concept, anticipating Howard in his 1896 *Die Stadt der Zukunft (The City of the Future)*, the 1912 second edition of which was subtitled *Gartenstad (Garden City)*. Fritsch took a highly racist perspective – completely add odds with Howard's – that later contributed to Nazi ideology and made Fritsch something of a prophet of Nazism. His other work, largely published in his journal, *Hammer*, was anti-Semitic and supremacist. Despite the fact that in 1910 German eugenicists were sitting on the board of the GGCA and the long tradition of town planning and architecture being hijacked in the name of racial cleansing and eugenics, the Association rejected Fritsch. This did not, however, stop the establishment in Bremen of a *siedlung* under the Third Reich: part garden city, part half-open prison, part eugenicistic selection centre.

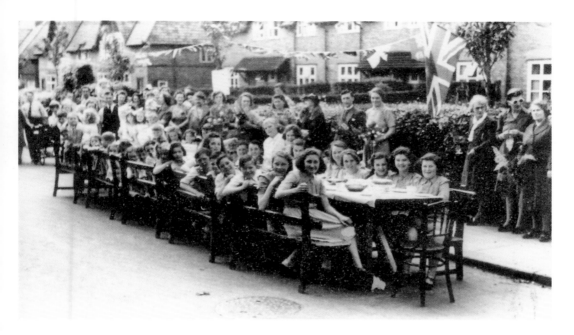

VJ Day

15 August 1945 – the day on which Japan surrendered and the Second World War was over. In Japan , the day usually is known as the "memorial day for the end of the war" (終戦記念日) the official name for the day is "the day for mourning of war dead and praying for peace" (戦歿者を追悼し平和を祈念する日). The official celebrations and victory parade in London took place, as here in New Earswick, on 8 June 1946. National pride and celebration takes many different forms: the new picture shows the English flags which adorned so many cars and houses during the 2010 World Cup in South Africa in June and July 2010.

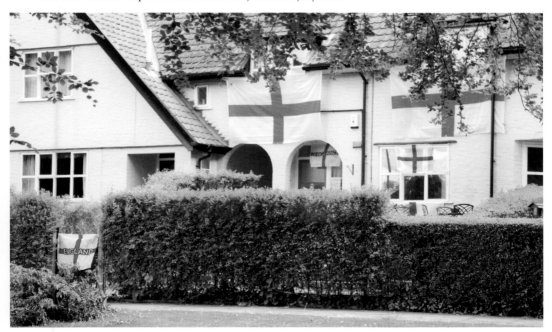

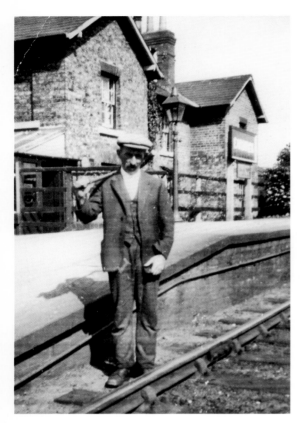

Jack Alan, Station Master
The old York–Hull line ran through New Earswick and stopped at Earswick railway station until its closure in 1965. The aptly named The Flag and Whistle pub now stands on the site, built in 1982. Hall's tannery is in the background of the inset shot. Fred Potter was the last crossing keeper before the station's closure: residents remember the metal hook he had in place of his left hand, lost in a railway accident.

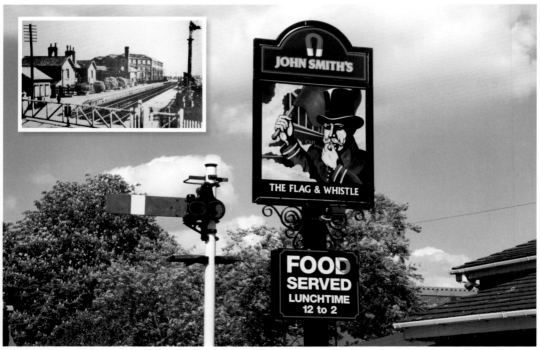

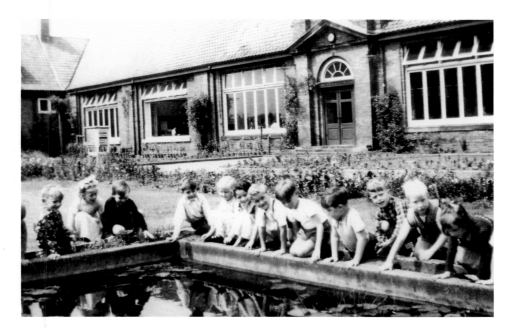

New Earswick Primary School and the suffragettes

The first school was in the Folk Hall set up in 1909 for 25 infants. The permanent school here was built 1912 for 352 5-14 year olds to save them the trek to Haxby Road. This (the 'Open Air School') was another model of enlightenment: boys and girls were taught the same subjects (science teaching was usually the preserve of boys) and all the windows faced south, opened to an extent of 18 feet and were at head level to maximise natural daylight. Each child had a notional 15 sq. feet of floor area – 50% more than was required by the Board of Education then. The photograph shows pupils enjoying themselves at the pond, now filled in. The fine clock on the cupola was donated by Joseph Stephenson Rowntree.

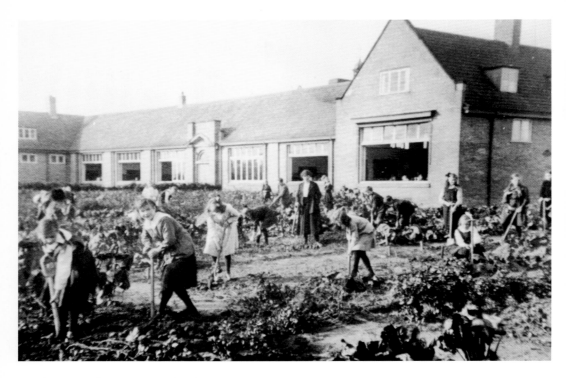

Gardening at the Primary School

Gardening was important at both schools even without the motivation inspired by digging for victory during the war years. This shows pupils gardening enthusiastically at the primary school. Two extracts from the Punishment Book: *28th February 1927: L. Smith age 10 – running home (twice warned) 2 strokes – hand; 12th December 1938: N. Peacock 11 – stealing 3 shillings – 3 strokes – hand at mother's request.*

Joseph Rowntree School - old and new
The first Joseph Rowntree secondary School was opened on 12 January 1942 by Rab Butler to cater for 480 children (in classes of 40) from age 11 from the village and surrounding area. As with the primary school it was nothing if not innovative for its time, taking advice, for example, from the National Institute of Industrial Psychology on ergonomic matters such as ventilation, heating and lighting. From the very start practical skills were valued and taught in equal measure to academic subjects, as the older picture here demonstrates taken from the 1946 prospectus. Adult education was encouraged too, in line with the Rowntree philosophy, with an Evening Institute of 350 students. The June 2010 Newsletter celebrating the new school demonstrates vividly just how much things have changed. The Costa Coffee franchise is the first to open in a UK school.

ARTS & CRAFTS

Both the Art Room and the Craft Room are larger than usual, and each has ample storage accommodation extending along the full width of the room. The desks in the Art Room are fitted with hinged lids to allow of them being used as easels. This room has been provided with special windows, the whole of the centres being in one large piece of plate glass. These windows face slightly north of east, so ensuring suitable lighting for colour work.

The girls learn weaving, embroidery, soft toy, glove and slipper making while the boys, in addition to ordinary bookcrafts, have constructed their own potters' wheels in the workshop. An electric kiln has been installed for the firing of the ware. The Trust has also provided a printing press, together with the associated equipment, so that the boys may practise typography, while willow cane basketry provides a useful outlet for those who are less skilled in crafts. Both rooms are fitted with gas and electric points, and each is also equipped with sinks. The closest possible contact is maintained between the teaching of pure art, design and craft, and also between the teaching of these subjects and that of needlework and handicraft.

The Joseph Rowntree School
right school to grow in

Newsletter

Mid-Term Edition June 2010

Dear Parents/Guardians

As we near the end of our first half-term of our Summer Term, we are heavily into examination season with exams being the focus for our Sixth Form, Year 11, Year 10 plus some Year 9 students. I wish every student success in these examinations and look forward to pleasing results in the summer holidays. I also want to thank our staff for the support they have given to our students, as well as yourselves - partnership working is definitely the way forward.

We enjoyed the prestigious Year 13 Leaving Ball at the Parsonage in Escrick on Thursday evening which was a great success. Equally, we look forward to our Year 11 Leaving Ball on 25 June at the Fairfield Manor, when all of our examinations are almost over. We have some very motivated students and I am impressed with the way they are approaching their studies and last minute preparations, along with revision sessions.

We continue to enjoy our new building and I love the way our students and staff are starting to "own" it - making areas inside and outside feel "theirs" and making it work for them. I am sure this will continue as we move through our first year in our superb new building. We had two evenings for celebrating our new school last week with speeches,

performing arts, food and drinks reception. It was a superb evening of celebrating where we are at on our "journey". I know we could have had a two week "opening" inviting every parent – however we had to limit it somehow. I would like every parent to have the opportunity to tour the building and I will be sending invitations in the near future to enable you to do this.

I was able to share our new school building news with a large audience in Beijing, China just before the Easter weekend. I was invited to talk at an International Conference and shared our news with a fascinated audience. Thankfully, I was able to return – a 4 day visit – before the volcanic ash saga!

I wish you and your families a very happy Half-Term holiday and thank you for your support in making The Joseph Rowntree School the special place it continues to be.

Best wishes

Maggi Wright
Headteacher

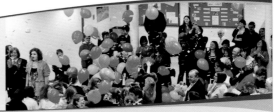
Opening day images...

" working together to achieve success "

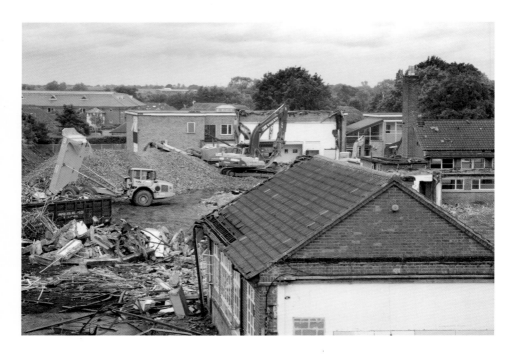

The Hub

There is no old picture here, just a contemporary shot of the old school being demolished. The other contemporary photograph demonstrates perfectly the modernity of the new school, designed and constructed with the same careful attention paid to lighting, space, heating and acoustics which exercised the designers of the old school. The Hub is a communal dining area complete with wide screen television. Airy and spacious classrooms can be seen on the upper floors.

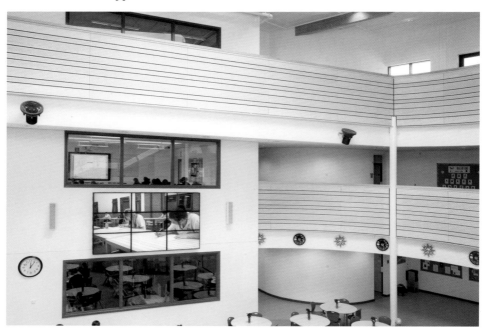

Gardening at the secondary school

The cost of the first school was £30,395 (excluding extra costs arising from war conditions) giving a per pupil cost of £63. The staff comprised the Head and seven men and seven women – each qualified in a particular subject. Special needs pupils were catered for. The school was designed as an open-air building: innovations included south facing large windows low enough for pupils to see out of when at their desks "capable of any required degree of opening" depending on the weather or time of year to provide optimum ventilation and lighting; ceiling heating panels; and "the long principal corridor (which) is slightly curved so as to minimise noise transmission by means of skin friction. The modern photograph shows students transfixed by the methane bubbles experiment.

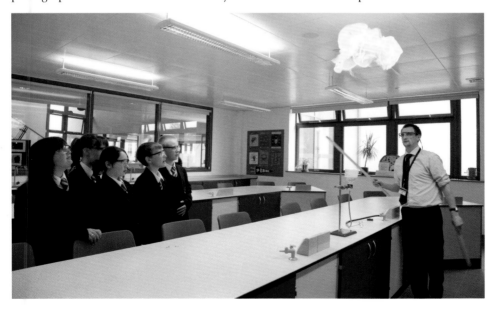

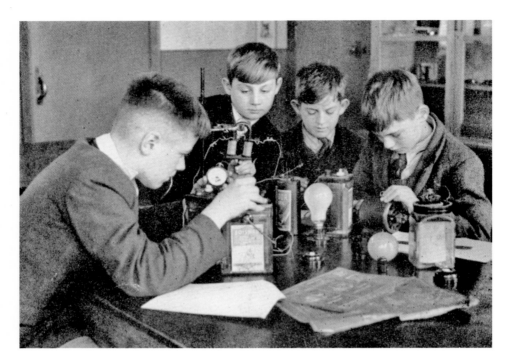

Physics, Design and Technology

Equipment included an electric kiln, a printing press and aquaria. Mechanical engineering included the conversion of an old car into a runabout truck. The new picture shows students learning the finer skills involved in drilling in a Design and Technology lesson. Today's students benefit from cutting edge laboratory facilities which are up to university and leading industry standard: nowadays these students need to be familiar and conversant with state of the art technology and equipment if they are to compete successfully in higher education and industry.

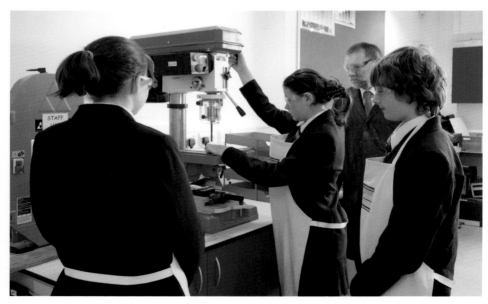

Domestic Science

Domestic science in the forties and fifties included cooking by electricity, gas or coal, working in the domestic flat adjacent to the department and used by the Domestic Subjects Mistress, assisting in the village Nursery School, and feeding the animals. The gym (see back cover) had room for a full-sized boxing ring when required and had a radiogram and piano for use during folk dancing. The sports hall in the new school has a wooden sprung floor and can be set up for a wide range of sports including volleyball and tennis within its 595 square meters. There is also a 57 sq. metre multi-gym with cardiovascular machines and free weights. These are complemented by six outdoor tennis or netball courts. The new photograph shows sixth form art students at work.

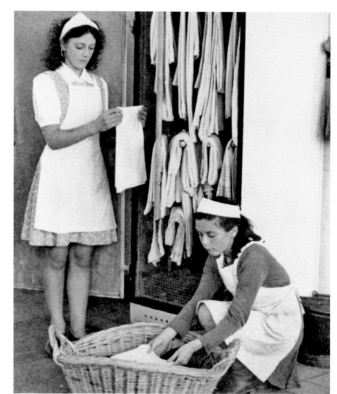

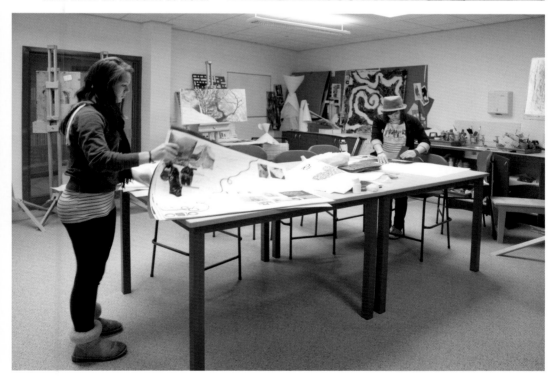

Joseph Rowntree School 1946 and 2010

100 or so years later the new school is a fitting twenty-first century testament to Joseph Rowntree's turn of the twentieth century vision. It cost £29 million and opened for lessons in February 2010. Like its predecessors it is innovative: one of the key features is a centre for autistic children offering specialist teaching and care for all children on the autistic spectrum. In November 2009 a time capsule containing a school uniform, a prospectus and dried pasta was buried by Year 11 pupils under a paving slab at the entrance. A delegation of teachers and educationalists from Bradford can be seen here, learning no doubt about the benefits of Joseph Rowntree's new school.